CAMPUSTOWN

Anthony Capps

CAMPUSTOWN

· A BRIEF HISTORY ·
OF THE FIRST WEST AMES

ANTHONY CAPPS

THE
History
PRESS

Published by The History Press
Charleston, SC
www.historypress.net

Front cover, top: mural by Ames Collaborative Art, author's collection; *bottom*: Ames
Historical Society.
Back cover, bottom: Lynn Lloyd.

First published 2016

Manufactured in the United States

ISBN 978.1.62619.990.3

Library of Congress Control Number: 2016944036

For Mom and Dad

CONTENTS

ACKNOWLEDGEMENTS

A great foundation for this book was established in William Page's 2007 survey titled "Fourth Ward: Ames, Iowa." Although many of the first Campustown stories and personalities are lost to history because they weren't recorded, the other foundation for the early years explored in this book is the archive of the *Iowa State Daily*. While some people might not think much of the newspaper because it's student-run—I spent many hours in the newsroom during my college years—the *Daily* is a quintessential source in the history of West Ames and Campustown because in the early years, it was the lone voice for local residents. While the *Ames Daily Tribune* and *Ames Evening Times* contain a wealth of information, West Ames received little attention in the early twentieth century. In its pages, the *Daily* also has advertisements, many of which are the only way we know long-ago businesses once existed.

A big thank-you also goes to Alex Fejfar and the Ames Historical Society for putting up with me in my many months of research, as well as Becky Jordan and the staff at Special Collections and University Archives at the University Library. Thank you also to the countless people who took the time to sit down and talk to me about their knowledge of Campustown or simply to recall their personal history with the neighborhood and what it has meant to them, including Lynn Lloyd, Dan Rice, Tom Emmerson, Kathy Svec, Dean Hunziker, Steve and Sherry Erb, John Huber, Ken Dunker, George McJimsey, Fern Kupfer and many, many more. And thank you to Mark Witherspoon and my parents for reading some of the early drafts.

Acknowledgements

And for the photos, a thank-you to the Campustown churches that opened their archives of histories and pictures, as well as Logan Gaedke and Julie Erickson for their help making some of the photography here possible.

INTRODUCTION

A few years ago, while working at the *Ames Tribune*, I was interviewing someone who said he was going to West Ames later in the day. I figured he was referring to the commercial district around West Hy-Vee, the old Ontario neighborhood at North Dakota Avenue and Ontario Street, or somewhere out west on Mortensen Road. I was wrong; the person was referencing Campustown. Six years of living in Ames, and this was the first time I'd heard Campustown referred to as West Ames. When people think of West Ames today, images of those places I deemed as West Ames are a fair reaction. They're near the city's western limits and are hubs for the surrounding neighborhoods. However, for most of the twentieth century, the downtown and centerpiece of West Ames was Campustown. Located just south of the Iowa State University campus, Campustown has been visited by hundreds of thousands—probably even millions—of college students, community residents and visitors.

Unlike the city of Ames and most Iowa towns in the late nineteenth century, the railroad didn't spur the creation of Campustown. Instead, it was the growth of Iowa State University, which remains the bedrock for Campustown's existence. Annexed by Ames in 1893 when off-campus lands were mostly barren, Campustown is a rarity in city development. The neighborhood has its earliest roots in the early 1900s, but that's more than thirty years after Iowa State welcomed its first class of students. A college community where the college came first and the surrounding community later is an uncommon story. Other notable universities that began in isolation

have similar stories—Texas A&M University, University of Maryland–College Park and Michigan State University, for example—but Campustown is special. It never incorporated as a separate town—though that could have happened during a secession movement in 1916—since Ames annexed it before any great expansion. This college community grew as part of a town nearly two miles away, crafting itself a separate city within a city.

Defining the Area

In this book, Campustown is defined as the land between South Sheldon and Ash Avenues on the west and east and Lincoln Way and Knapp Street on the north and south. Nevertheless, the surrounding neighborhoods will be mentioned in this book because so much of Campustown's history is deeply tied to them and, of course, Iowa State University. Several buildings and events bordering Campustown—Welch and Crawford Schools, the Iowa State University Memorial Union, the 1988 VEISHEA riot—will be discussed because of the importance they played in Campustown life. Campustown wasn't named until 1922, but I'll always refer to the area as Campustown; other nicknames will be explored, too.

Because the West Gate center—that small commercial node on West Street just west of campus—is covered here in its early years, a chapter will discuss its later history. Though not a part of Campustown, the small locality has retained its business presence for more than a century and has cultural ties to Campustown.

For terminology, **West Ames** refers to all of Ames that was west of Squaw Creek. For its first seven decades, the area was frequently referred to as the **Fourth Ward** because it was a separate electoral ward. Though the term will be used occasionally in quoting old newspaper pieces, I've otherwise eliminated it because the term's relevance vanished after a redrawing of precinct lines in 1963. **West Gate** refers to the neighborhood around West Street and its commercial strip. **Iowa State University** had two names prior to its current one: Iowa Agricultural College and Iowa State College. By the time Campustown began to develop, the name was Iowa State College and remained so until 1959. I will usually call it Iowa State or the university for consistency.

Several streets have a prior name—and sometimes two. I've minimized references to former names for consistency, but the old names are occasionally

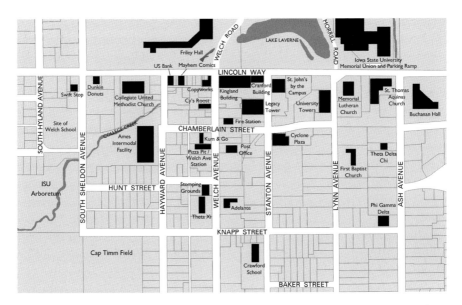

A plat map of Campustown in early 2016 with some buildings and locations highlighted. *Author's collection.*

noted alongside a street's current name. Addresses are noted on occasion. To put them into context, I'll sometimes state what is currently (July 2016) or was recently at the location.

CHAPTER 1

THE PIONEERS

When Lewis Badger arrived in Story County from Illinois in August 1858 with his wife, Mary, and young son, Henry, he kept a diary. It's the earliest (and perhaps only) record of what the land and life was like before the establishment of the agricultural college and farm that today is Iowa State University. Though dry and lacking comprehensive detail, the diary lets us see the struggles and marvels that Badger withstood and the handful of locals he knew. On arrival, the Badgers could only take the train to Iowa City because that's the farthest west it reached. The land he owned would be sold to the state in 1859 for the college, but upon his arrival, he rented a cabin somewhere south of his land—and the future Campustown area. When Badger and his family wanted some meat, it meant going out to hunt animals such as rabbits, squirrels, prairie chickens and quails, all of which roamed the land. The terrain required plenty of mowing, and after a couple of months, he bought some livestock (a cow, a calf and pigs). He tilled the land, chopped trees and built fences but had to travel often to buy equipment and food. At the time, the nearest town with businesses was Nevada, which also included the nearest post office. Badger didn't live in Story County long. He wrote about state officials surveying the area for the agricultural college, and upon the land sale to the state in the summer of 1859, he returned to Illinois before heading out to Nebraska, where he lived until his death in 1905. Badger wasn't the first settler, but he was one of the first people to cultivate the land.

THE FIRST SETTLERS

Before the first settlers moved to Story County in 1843, the land was open prairie spliced by rivers and creeks with some groves. For more than a century before the first French explorers claimed the area in the late seventeenth century, the lands were claimed by the Ioway until the 1830s and then the Sauk and Meskwaki after they were forced from their Illinois home. After the first European claims, the region was administered by the French, Spanish and then the United States after the Louisiana Purchase. However, the Story County region remained largely uninhabited by even the natives, who preferred settling next to rivers. The banks to the county's main waterway, the Skunk River, were too wet and muddy to support any building, and they remained that way well into the nineteenth century. For the early white settlers, the county's highlights were the tall prairie grasses and wildlife such as deer, elk, black bears, mountain lions and wolves.

The land that would become Campustown was a predominantly flat area. The eastern half was a swamp that prevented large-scale development for years. The western half was ideal for settlement, with College Creek serving as the western and northern border. There was a well-defined ridge in Campustown that was located along Stanton Avenue (originally named Ridge Street). There are a few mentions of Indian relics found, so the location may have been a camping spot. To the northwest, Clear Creek and its woodlands had carved a rolling terrain.

In 1858, two years after a failed attempt, Iowa lawmakers successfully passed legislation to create a state agricultural college. On Christmas Day of that year, Story County residents gathered at the county courthouse in Nevada to form a committee because they wanted to be the college's home. By February 1859, residents had secured the financial means through bonds and land donations that would earn the college for the county, and in July, the last properties were purchased by the state for it. That key land—extending from North Riverside Drive to Sheldon Avenue and from Lincoln Way on north—is still owned by the university and includes the main campus grounds. The land, like Campustown's, was a flat prairie with ideal soil for farming and research, though a little drainage was required.

During the time in between the college's founding and its opening a decade later, the railroad crossed Story County. With an undetermined route between Nevada and Boone in 1863, Story County's and Campustown's futures could have been much different. Washington J. Graham, who had

fought for the college to be located in Story County, believed his land south of campus would best serve as a town halfway between the two towns. That year, Collegeton was laid out but not recorded because the railroad's future was still up in the air. Washington's proposed town (called College Town in some sources), located in what today is the land south of Lincoln Way and between Ash Avenue and the halfway point between Welch and Stanton Avenues, was between sixteen and twenty acres and included grounds for a railroad depot. In the end, railroad magnate John I. Blair rejected the route, and the Cedar Rapids & Missouri River Railroad would go north of the campus, where the land was flatter and offered a more direct route to Boone, which was then called Montana. In November of the following year, Ames was platted—though the land wasn't much better than that of Collegeton, which was wetland the early settlers would need to overcome. Had the route gone south, Collegeton, not Ames, would be the city between Nevada and Boone.

Despite Graham's failed attempt at establishing Collegeton, he is one of the founders of the Iowa Agricultural College—many accounts state he was the most energetic and active supporter, though his personal interest in selling his land to the college and/or railroad must not go unnoticed—and he was the first settler of the land that is now not only Campustown but also the College Heights, Colonial Village and South Campus neighborhoods.

Born in 1827, Graham left his home state of Virginia to follow his future wife, Flora, to Iowa. In 1853, he arrived in Story County, and on May 15, 1855, Graham received his land patent from the U.S. government for the land that is now between State and Beach Avenues on the west and east and Lincoln Way and the Dairy Farm on the north and south. In 1856 or 1858—it's unsure exactly when—he built not only the first house in West Ames but also a house that predates the first house built in Ames.

Like most dwellings of the day, it was a log cabin—twenty-four by eighteen feet—and though we aren't positive where the house was located, it's thought to have been around the southeast corner of Lincoln Way and South Sheldon Avenue. The inside sills, or beams, which supported the house on its foundation, were hewn timber and constructed with square nails. The outside was white pine—tongue and grooved into place—and likely came from Minnesota or Wisconsin. The wood, popular in the nineteenth century, would have been shipped down the Mississippi River to Clinton or Dubuque and then likely delivered by ox. The entrance was a Dutch door, a door divided so that the bottom half remains closed while the top half opens, and there was a trapdoor in the floor, likely to access storage. In 1976, the Sun

Dial chapter of the Daughters of the American Revolution placed a plaque at the site that can still be seen.

The opening of the Iowa Agricultural College and Model Farm in 1869 didn't spur any development in the area. With travelers heading west out of Ames, Lincoln Way—then simply called "the highway"—was extended to Sheldon Avenue, where it turned north to West Street and then continued west. Prior to this, Lincoln Way turned north near the Knoll and continued across campus to West Street. However, travelers still liked traveling through campus not only because of the scenery but also because the roads were better. The grounds near Lincoln Way and Sheldon Avenue turned into an unofficial camping ground in the 1890s. Tribesmen and gypsies would gather near the well next to Professor Anson Marston's cottage to ask for cold water. General travelers would also park their wagons for an overnight stop at the location; the area lacked any hotel services. While the east–west route was the main route through the area, by the early 1880s, Beach Avenue extended all the way to Kelley, and Ash Avenue, where early pioneer Daniel McCarthy built his farm, already stretched to Mortensen Road, which itself went from Ash to South Dakota Avenue. Hyland Avenue also stretched north to Ontario Street, but crossing hills and the river prompted a zigzag road.

There was plenty of land speculation in the early years, but only a few tracts of land were divided up for development. Adonijah Welch, Iowa State's first president, and his wife, Mary, were some of the early land buyers. Welch was a participant in the California gold rush and invested in lumbering and fruit growing while living in Florida, where he also served as a U.S. senator. He also had a knack for land development—Central Campus was his idea—so it should come as no surprise that in 1870, the Welches bought eighty acres south of campus on Lincoln Way. Today it's the Greek Letters and College Heights neighborhoods. Some other college-related people speculating west of Ames were William Fitchpatrick, the first resident of FarmHouse; his son, Joseph Fitchpatrick; and Joseph L. Budd, head of the horticulture department. Welch had other properties in the area in the 1870s, too. He owned some land that today is south of the site of the old Ames Middle School on State Street and continuing to Mortensen Road. On the other side of the vicinity, he owned a bit of land on Squaw Creek that even today hasn't really developed. It's where South Fourth Street crosses the Squaw and includes a bit of the property that's home to the new Stadium View Suites (formerly the home to Riverside Manor nursing home). On the south side of town, Welch also owned land that is a small neighborhood south of Highway 30 on Worrell Creek.

In 1876, Mary Welch platted one three-acre lot in the northwest portion of their college adjacent property, and Adonijah platted two one-acre lots to its east. Edgar W. Stanton, then assistant professor of mathematics and secretary to the College Board of Trustees, purchased the three-acre lot, perhaps speculating himself or thinking about building a home for him and his wife-to-be, Margaret MacDonald, whom he would marry the following year. In 1879, with a campus residence available to him, Stanton sold the land to Adonijah, who soon built The Gables. The Welches lived in the two-story brick house until 1885, but it remained a home for college presidents—William Chamberlain and William Beardshear—until The Knoll, which is still the home of the school university president, was built. The house was purchased by Professor Millikan Stalker, dean of veterinary medicine, in 1899 and went to his sister, Sallie Stalker Smith, after his death in 1909. As the International House and property of the university, it was razed in 1963 to make way for Buchanan Hall.

The First Landowners

By the 1880s, after various prospecting, the remaining land south of campus was owned by Philander L. Porter, who also owned all the land bordering the west side of the college and was one of five who sold their land to the state for the college campus. An original member of Ames's first church, First Congregational Church, Porter was born in Ohio and later made his way with some family to Iowa. Porter lived on a farm around the current West Gate neighborhood and made a living in the dairy and brick and tile industries. His creamery was a first for the area, and the butter was big business. In 1881, as his popularity still grew, Porter moved his creamery business to Ames and patented his own milk can design—to keep the milk cold—that would be used by numerous customers. In 1880, Porter himself moved to Ames, and he sold the creamery operation in 1882.

Porter is also one of several people who owned the brickyard west of campus. The brickyard started in the 1870s, but brickmaking in the area began with the first buildings at Iowa State. The kilning for bricks for Old Main, the school's original central building, was done somewhere on Graham's land south of campus—though the bricks turned out to be unusable. The brickyard—then called the Clear Creek Tile and Brick Works—was located south of Oakland Street and was owned by Porter in

the 1880s. He made good money in the business, too. In 1884, Porter sold it before leaving Ames. After a few months, newspaper mentions go quiet. In 1894, J.A. Kerr sold the place to a man prospecting for coal, but coming up empty-handed, the man sold it the following year. The operation would go through several more hands before 1900. The extraction of clay from the ground in the early twentieth century would create Briley's Pond, which was renowned for its tug-of-war competition between students.

In the 1880s, Porter divided his southern land between his son, William; his wife, Susan; and his daughter, Harriet, who had as much land as the other two combined. She wasn't favored; rather, the land included College Creek, which formed hills that cut through the landscape, hindering development.

THE DINKEY AND ANNEXATION

The area continued in its isolation through the 1880s, which led to a sense of confinement by the 1890s. The college's main dining hall was nicknamed Andersonville for the hall's steward, C.V. Anderson, but it also referenced the Confederate prisoner-of-war camp. Even President Leigh S.J. Hunt paraded about Ames whenever he got to escape the college routine. Transportation to Ames, which was 1.98 miles away, was limited, too. People could walk the railroad tracks north of campus and then cut across a pasture to a footpath to Ames, walk along Boone Street (Lincoln Way) or take the Nichols & Maxwell livery—also known as "college bus." The latter two were unreliable because too much rain or snow would make the road impassable and could shut down bus service for several days— plus being rather expensive at ten cents one way. Ames residents had the luxury to travel because of the railroad. Those near Iowa State didn't have such a service in its early years. Though there wasn't much development beyond the college and there were only a few sporadic houses and farms in the area, it was a community dependent on the roads for travel at a time when such travel could be easily thwarted by weather. A railroad gave life to a town and connected it to the rest of the world. It meant nearby farmers could ship their livestock and dairy products and a town could send and receive mail and have a telegraph. Without a railroad, the longevity of a town, as evidenced by nineteenth-century Iowa towns that weren't on a railroad line, was limited. The college had talked with the Chicago & North Western Railroad, which now operated the line through

Story County, on more than one occasion about building a depot north of campus, but there was never an agreement.

The Ames & College Railway was founded in September 1890 and was an immediate blessing for West Ames. By September 1891, the Motor Line was operational, and the treacherous travel to and from downtown Ames was reduced to minutes. The train was quickly named the Dinkey, and though the origin of the name is unknown, it likely refers to the small size of the engine or a manipulated spelling of "donkey," a type of locomotive used for hauling rail cars. Though the only place to travel on the Dinkey was Ames, it made the escape from campus life easier and cheaper at five cents per way. Even with crowded cars and sometimes slow travel, the Dinkey was a source of pride for students and faculty. It was their special mode of transportation. The effect the Dinkey had on off-campus development was limited. Even with the sense of isolation waning, students and faculty were more apt to live (and build) in Ames since the train made it feasible. Even before the Ames & College Railway, campus was becoming cramped. In the fall of 1890, the student newspaper noted that the college was dangerously close to its housing capacity, and all reserves were already being utilized.

The newfound bond between the city and the growing college attracted the attention of city officials. In 1890, Des Moines annexed several young neighboring towns such as Capitol Park, Chesterfield and Sevastopol and, by doing so, increased its land size by more than 600 percent. Ames was soon to follow. In 1892, Grand Avenue was as far west as Ames reached, but in the proposed annexation of the college and surrounding area, the city would stretch to Campus Avenue. The clearest reason for the annexation was the population boost. According to the 1890 U.S. census, the twenty-year-old Ames had a population of 1,276. Adding the college and surrounding land would put the population above 2,000, which allowed the city to apply to the State of Iowa to become a city of the second class.

In November, the annexation issue came before the city council, and it was determined that a public vote would be held on December 31 to decide. Leading up to the vote, both city newspapers favored the annexation; the student newspaper was on break. There was no organized opposition, so to no one's surprise, the citizens of Ames voted overwhelmingly—120 to 9—to annex the land. On January 2, 1893, the annex was placed into the record, and West Ames was born. When the city took its own census in 1892—which was recorded in 1893—the population had nearly doubled to 2,489, of which about 20 percent were college students.

The first spring 1893 issue of the student newspaper, the *I.A.C. Student*, read, "And so now we are living in the city, the limits having been extended during the winter. Boys, now [let's] wake up and have our say in city matters, [let's] elect a member to the city council the coming election. We are enough to carry the day."

CHAPTER 2

WEST AMES IS BORN

With the city's annexation, the area around Iowa State was frequently called the Fourth Ward because it was a new electoral ward for the city of Ames and situated more than a mile away from the other three wards. Growth in West Ames didn't occur overnight. During the 1890s, Iowa State's student population tripled, but for most of the era, land speculators claimed the land. When houses began to rise at the turn of the century, they were large and went up fast, and a few businesses providing the basics for residents soon followed.

Building would be scattered in Campustown, but land speculators were an immediate arrival at the turn of the century. Lots could be purchased for a few hundred dollars, and many were bought and sold several times in the 1900s without ever developing. Like many other Iowa State/Campustown–related communities, a steam engine arrived in the 1890s to transport students and faculty back and forth to the neighboring city. However, most of those other places—like Texas A&M University and Michigan State University—had nearby cities that were easily walkable. They might take a while to travel, but it could be done; the train just sped it all up. They didn't have an obstacle in the way like Squaw Creek. It's that part of the story that makes Campustown's infant years unique. The isolation of the campus would start to vanish by the 1900s as Campustown (and West Gate, too) rose from the ground, but spreading its wings and achieving a vibrant business community would still take more than a decade.

LIFE IN THE 1890s

Under the leadership of William Beardshear, Iowa State came into the modern age in the 1890s. Among other things, the water supply, electricity, sewers and telephone lines were all updated during his administration. Margaret Hall, a women's dormitory, provided a new dining hall when it opened in 1895, but residence for the men was shifting away from campus. An 1887 rule requiring all students to live on campus unless a valid excuse was approved by both the steward and president was antiquated in a few years. The student newspaper noted in 1890 that enrollment would be right in line with capacity. By the spring of 1892, with 180 more students, several were boarding in town because the college had turned them down. The "day student," a student who doesn't live on school grounds, became commonplace, and within a few years, student opinion was okay with the shift because without the college overlord there are additional freedoms. There was a student appreciation for residents, too, because so many opened their homes to them. But by 1898, some residents were concerned about the growing student population and whether the dormitory system would be dismantled, forcing the city to pick up the slack.

Some professors and landowners were starting to build homes south of campus. Alfred A. Bennett, head of the chemistry department, had a house on Boone Street (Lincoln Way) down the street from The Gables, and in 1898, he built another house next door. The new head of the English department, Alvin B. Noble, and his family would live in his former one. However, there remained little development in Campustown since the land was in the hands of a few landowners who weren't selling properties.

In September 1899, development in West Ames reached a landmark. Six married couples—Joseph L. and Sarah Budd, Clay and Emma Foster, David and Eleanor Ives, William and Amanda Diggins, William and M.E. Cameron and Isaac and Martha Ellis—platted ten rectangular, mostly equal-sized building lots between Boone and West Streets and Pike (now Sheldon Avenue but occasionally called Broad Street around the turn of the nineteenth century) and Hyland Avenues; the latter street was established with this plat. This land, directly west of Iowa State, would be home to some of the earliest residences. Some of those platting families settled in the area, too. Joseph Budd was now a professor emeritus of horticulture. Clay Foster had a farm west of town. David Ives operated a transfer line in the area for several years. William Cameron, along with Jake Lyon, was one of the people who attempted to keep the nearby brickyard going. And Isaac Ellis was a

local farmer and pastor of the Friends Church, which would be built on one of the lots. The surrounding land to the west and north was platted out into larger tracts of varying size and shape due to the hilly landscape. At the same time, the land farther north was divided into seven large tracts, none the same size. There was also a motivation for platting because of the city's laissez-faire attitude that would be the source of West Ames's chaotic blueprint.

Campustown Platting Begins

The first Campustown platting occurred in May 1900 on the land that's now the heart of the neighborhood. The land was owned by Robert H. McCarthy, an employee at Tilden's clothing store downtown and son of Story County pioneer Daniel McCarthy, and the economic laissez-faire attitude on town planning is clearly visible. The foundation of McCarthy's plat, named Beardshear's Addition after the then–college president, was Welch Avenue, as the plat stretched from Lincoln Way to Knapp Street. On the west side were Hunt, Knapp and Chamberlain Streets and two street-enclosed blocks with a north–south alley. However, no provisions were made to extend the streets on the east side of Welch. The northwest area of Beardshear's Addition had a diagonal cut through it because of College Creek, which was treated as a scar on the terrain. Today, culverts carry the creek under Lincoln Way and Hayward Avenue, with a storm sewer under the properties in the block's northwest corner. After selling a few Beardshear's Addition lots, Robert left Tilden's and opened his own clothing store downtown.

A year after Beardshear's Addition, David and Mary Parker, John and Hannah McDaniel, William and Ariel Gossard and James and Lucinda Sargent platted out another large chunk of land that completed the Campustown area. The west side of this addition, called Parker's Addition because the Parkers owned most of the land, began where Beardshear's Addition ended and extended to Ash Avenue. Stanton and Lynn Avenues (originally Ridge and Swamp Streets) were included, but their widths varied and were below the later-standard sixty-six-foot width. No east–west streets were established either, including Knapp Street at the south end. A majority of the lots were unequal in size and shape, yet—to be technical—the plat is composed of an entire quarter of a quarter, according to the Public Land Survey System. A year prior, David Parker, who then owned all of that land, created three unconnected and different-sized lots, which were owned by

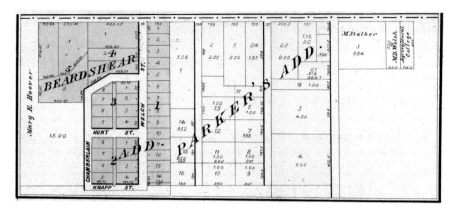

Campustown's first two plats were Beardshear's and Parker's Additions. Both had some setbacks in their disorderly design caused by laissez-faire attitudes. *From* 1902 Story County Atlas.

the people who were a part of Parker's Addition. Of the plat's twenty-four lots, twenty-one were owned by the Parkers. Lots like the one owned by the Sargents in the southeast portion of the plat were larger—three and four acres—but when sold and subdivided years later, they continued to dispel any chance of uniform town planning. Beardshear's and Parker's Additions, despite not looking suitable or practical for any long-term, uniformed city planning, were approved by the city.

To the east of Parker's Addition, William H. Donaldson platted about forty acres in 1900, but it never developed. On the other hand, west of campus continued to grow. In February 1901, the land north of West Street and to the curve of Sheldon was subdivided into eighteen building lots. In June, Hyland Avenue was extended north of West Street with six new building lots, and another four were added in early 1902.

EARLY RESIDENTS

New landowners wasted no time building. With more lots and better accessibility to campus, the West Gate neighborhood developed quickly. Upon entering the campus, West Street continued straight to Central Campus, and at this time, campus housing was concentrated to the north, where Margaret Hall was located and Parks Library now stands, as well as East and West Halls, which were located on the drive. The only south

entrance to campus was east of Ash Avenue at the Knoll. Despite the lack of immediate access, by the fall of 1901, construction was booming both west and south of campus as the landscape was dotted with new residences. "Houses seem to be springing up in the night, almost," stated the *Ames Intelligencer* that September. A campus entrance at Welch Avenue was created around 1903.

The best examples of early building and to see where students were living are the early college directories. The houses of David Parker, Hawley Miller, John McDaniel, Seward Mabie, Isaac Otis, Clay Foster, Alexander Gray and E.C. Tuttle were home to dozens of students in 1901—and these places weren't there three years prior. By the fall of 1903, some other new houses for students were those of Carrie Minert, Nels Madson, William Greer, Hugh McBurney, Harvey Illsley, Norman Storey and Chester Rubel. Not all of these places were shared with the owner's family and students, but some—like the Mabie, Minert and Gray houses—were. To the east of The Gables and the Noble and Bennett houses were others such as college professors Adrian M. Newens, William H. Stevenson and Louis H. Pammel. And like the townspeople, faculty began building homes and opened them to students.

Located behind Welch Avenue, this old boardinghouse, which is still used today, was built in 1904, making it one of the oldest buildings standing in West Ames. *Author's collection.*

The other type of early residence was the clubhouse. Fraternities were banned from Iowa State in 1891 after student opinion disapproved of them and many students actively protested against them. A few clubs had popped up on campus in the late 1890s and were tolerated by the administration. Now with a lack of housing on campus, many clubs sought residences to call their own. The Sunset and Hyperion Clubs settled on West Street, and Noit Avrats, the oldest club (see chapter 6), settled right across the street from campus at the West Gate entrance. To the south of campus, Welch Avenue became a preferred corridor, dotted with houses all the way to Storm Street by the end of the decade. Within a couple years, Kibby, State and Sunnyside Clubs had homes on the 200 block of the street. The Parkers, who lived on Duff Avenue, built two residences—East Parker, where St. Thomas Aquinas Church is now, and West Parker on Lynn Avenue, where the Sigma Alpha Epsilon house is now. They became quite popular and were part of a small trend to name houses after their owners—Miller's, Olsan's and Otis Clubs, for example. Several other clubs would find residence in West Ames, though many would have two or more houses through the years, such as the Gamma Alpha, Arcade, Adelante and Metropolitan Clubs.

But not every part of the plattings developed. Properties along Hayward, Hunt and even Knapp didn't develop until the 1910s, and much of Lynn Avenue, which was named Swamp Street for good reason, remained undeveloped because of the swampy land. (Though it's uncertain officially how Lynn Avenue, which first appears in the early 1910s, received its name, the origin of the word Lynn comes from "lake," which is a lot better than "swamp." Birch Avenue was also used on rare occasion, too.) However, during this time, many properties were regularly changing hands as land speculators and local investors swarmed on the new real estate.

On the map in the spring 1904 *College Directory*, Ash Avenue had three houses located on or near the street; this number was up to nearly twenty in 1910. In the West Gate neighborhood, Hyland Avenue, with its many smaller lots, had the most buildings, climbing from roughly thirteen to around thirty-six by 1910. However, it was Welch Avenue that proved to be the preferred location. It didn't have as many buildings as other streets (from thirteen to twenty-eight), but student clubs preferred the street. Later in the decade, Iowa Club, Colonials, Utopia Club and Omega Delta were some of the early clubs that would call Welch Avenue home. However, with so much quick building, the quality of many buildings would be questionable after a generation.

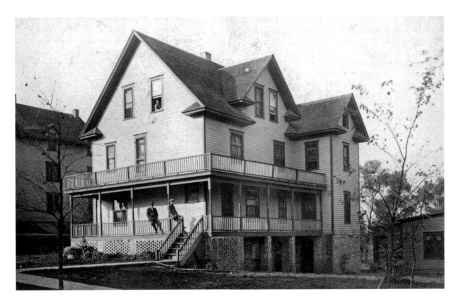

The Zimmerman House at the corner of Welch Avenue and Lincoln Way was one of the early boardinghouses, containing twenty-two rooms. It burned down in June 1910. *Courtesy of Jerry Litzel.*

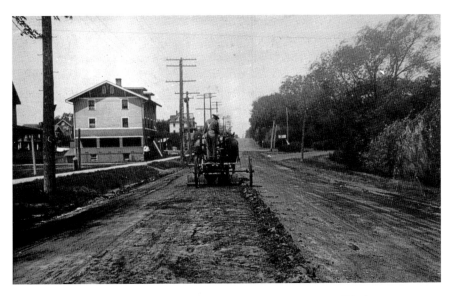

A road-maintenance worker grades Lincoln Way near Lynn Avenue. The house, Atkinson Lodge, was razed in 1956 to build Memorial Lutheran Church. *Farwell T. Brown Photographic Archive.*

THE FIRST BUSINESSMEN

The earliest businesses in West Ames were Porter's creamery and brickyard, and the first family in Iowa State's FarmHouse, the Fitchpatricks, ran a hardware store. And of course there was Iowa State. However, they all predate or have roots in the area from before the Ames annexation in January 1893. Many of the other early businesses were various local operations with an agent on campus, most notably laundry services. The Ames Laundry Company and Wing's Model Laundry, to name a couple, all had agents on campus around the turn of the century. On occasion, students were campus agents for high-end items such as fountain pens and typewriters. There was a small bookstore in the Hub, too. One on-campus business was a popular tailoring business started by Adolph Wettstein, an Iowa State alum, in the Creamery Building not long after the turn of the century. Dolph, as he was called, moved downtown in 1906.

The first noted business to appear in West Ames occurred in 1899. Frank J. Olsan was an immigrant, born in 1859 and arriving in the United States from Moravia in then-Czechoslovakia in 1887. Four years later, Olsan, whose family had been horticulturalists for nearly five centuries, settled in Story County, and in 1898, he bought some land neighboring the college— north of Sheldon Avenue where it curves to the northwest—from Joseph Budd. Today, it's the Sheldon Avenue Extension road. A year later, the Olsanville Greenhouse opened. The steam-heated greenhouses were a first for Ames and offered the community fresh vegetables and flowers. Business was so good that within months, Olsan was already planning on expanding into fruits and vineyards. In the early years, the family sold vegetables to Iowa State College and Ames grocers who wanted fresh produce. An active member of the Iowa Florists' Association, Olsan eventually rented space downtown and opened a store, Olsan & Sons, in 1909. Two years later, work began on the Olsan Block, a concrete building—another Ames first—that still stands at the southwest corner of Main Street and Burnett Avenue. In its early years, the dance hall on the second floor hosted several dances for fraternities and student clubs.

In 1916, Frank was ready to retire, so his sons, Charles, William and Milos, continued the business. The sons, who never dropped Frank's name from the store, continued to find great success. In 1921, they opened a store in Nevada, and by 1931, the glass space at the greenhouse had more than doubled to thirty thousand square feet since Frank retired. Business also reached to the Des Moines and Chicago markets. In 1933, the downtown

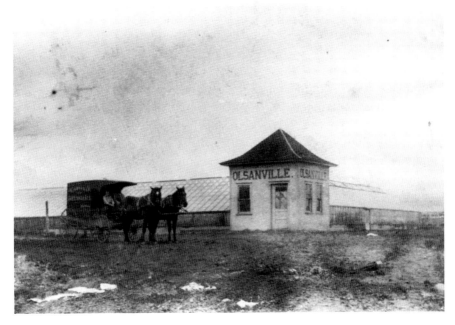

The Olsanville Greenhouse was operated by Frank J. Olsan and, after his retirement, his three sons. It began operation in 1899. *Farwell T. Brown Photographic Archive.*

store moved to a new location, and in 1935, Iowa State's alumni association purchased the eight acres where the greenhouse stood. Frank died in 1950.

One of the early recorded businesses on campus was the College Barber Shop in the basement of Old Main. It was operating when the building burned to the ground in 1902, but under the ownership of Fred I. Banks, it reappeared in 1905, briefly in the Creamery Building, before moving to the chapel basement in Morrill Hall. After four years at that location, it moved to the southwest corner of Welch Avenue and Lincoln Way. Banks sold the business in 1908.

The first business that would directly serve some basic needs of West Ames residents arrived shortly after the turn of the century. Hawley D. Miller was a seasoned businessman in the 1890s, operating drugstores and then serving as the owner of Peoples' Bakery and Restaurant on Main Street. In June 1901, he and his wife, Isabella M., purchased some of David Parker's land south of campus. The New York natives built a building for a general store and student rooms on their lot at the southwest corner of Ash Avenue and Lincoln Way, where St. Thomas Aquinas Church is today. At his store, which opened in the summer or fall of 1901 and was referred to as the

College Store, customers could purchase cigars, confectioneries, soda and ice cream—all staples of the early West Ames businesses to come.

Not much later, Henry E. Briley started West Ames's first meat market. Briley's business beginnings are a bit unclear, but he operated some meat markets and was a livestock trader in Ames in the 1890s. His West Ames business started in the basement of Kerr Building. Kerr operated the brickyard for a while in the 1890s, so Briley's first business location must have been in one of those buildings. He soon left for another building and was there for about four years. Then he moved into a much larger building, one that he would operate from for years. It was at the north end of Sheldon Avenue, as the road began to curve and across the street from Olsanville Greenhouse. This was also Briley's home. His sons, Ralph, James and Newton, who also helped with the business, lived in houses a block to the west on Hyland with their families. Their backyard was the old mill, and their name became attached to the clay pond (Briley's Pond) once it became a location of some student activity. The first advertisements for Briley's meat operation are for the College Heights Meat Market in the spring 1903 *College Directory*, but within a couple of years, the Briley Store and Briley & Sons had become more common. Briley later branched out to operate a general store rather than strictly a meat market and would occasionally have partners in the business.

In May 1904, Miller sold his business to a new man in town, George H. Champlin. But it was his son, Albert Louis Champlin, who would be the head of the store. The two didn't waste time, and by the fall, the general store had moved to the corner of Welch and Lincoln Way, a lot that Howard had purchased a year earlier.

CHAPTER 3

GROWTH, GRIEVANCES AND SECESSION

Building continued to boom well into the 1910s but still wasn't able to keep pace with the growth at Iowa State. Speculation continued to thrive, though it was concentrated on land rather than houses on the properties. The creation of more lots depended on the resistance of adjacent landowners, who were often farmers. In land that had been platted, larger plats were frequently subdivided into smaller lots for residential development. The sporadic, patchwork growth coupled with the city's continued laissez-faire development attitude meant there wasn't a long-term plan for managing its growth—a city manager wouldn't be appointed until 1920, and Ames's first zoning ordinance wouldn't occur until 1930. It wasn't until 1908 that Knapp Street was pushed east of Welch Avenue, overcoming a major defect of Beardshear's Addition. Streets varied (and still do) in width. Welch Avenue is the standard 66.0 feet, but Lynn remains at 50.0 feet. Stanton Avenue is 63.8 feet until it's south of Knapp Street, where it's only 50.0 feet. It also doglegs a bit, but not nearly as much as Hunt Street. Neighboring Campustown to the east, the College Heights and Greek Letters neighborhoods, established in 1913 and now home to numerous Greek houses in the north, provided more than 140 building lots, but its curved boulevards didn't pair with anything in the area.

The local townsfolk were pleased to be part of Ames and the services that came with being part of a larger, established municipality during the Progressive Era. Iowa State was the source of pride in West Ames, as well as the foundation for everything. Without Iowa State, neither Campustown nor

West Ames would exist. With growth both to the west and to the south of Iowa State, two commercial nodes arose. One was centered on West Street and another at the corner of Welch Avenue and Lincoln Way.

The pride in the school didn't necessarily extend to the city. With a school where science and engineering were pillars, the town around it lagged behind in many ways. One of the driving forces from inside West Ames for improvement was the Fourth Ward Civic Improvement Society, a women's society dedicated to improving the area. It raised money and awareness for necessities like bridges and water fountains. One of its most popular achievements was the building of a second waiting room at the West Gate station.

A feeling of animosity would overcome West Ames and spill into a secession movement prior to World War I, but the feelings of the movement can be seen only a few years after the building boom began. Criticizing the lack of sidewalks on April 19, 1905, the *I.S.C. Student* wrote, "This annexed section in easy access as it is to the college, will probably experience a greater growth than any other portion of Ames. Why then is it so sadly neglected?"

A.L. CHAMPLIN AND BUSINESS BOOM

Born in Chariton, Iowa, in 1874, Albert Louis "Lou" Champlin wasn't the first businessman in West Ames, but he would be the most influential. In the fall of 1904, he and his father, George, reopened their general store at the corner of Welch Avenue and Boone Street (now Lincoln Way) in a twenty-four- by forty-foot building. At the store, one could buy various groceries, candy, fruit and student supplies. In the spring of 1905, for a brief time, W.L. Macklin, physician, surgeon and optometrist, had an office above it. In 1906, Champlin married Angie Culbertson, who was his first cousin, and his operations were now three departments: grocery, meat and livery. At its peak, Champlin's barn, located to the east of the store, had twenty-eight horses, as he handled most of Iowa State's livery needs. As times changed and horses were replaced by the automobile, he built Champlin's Garage. Champlin was also buying nearby lots in the area and building residences—the rental business was booming.

For businesses, neither West Gate nor South Gate—as the Welch Avenue entrance was occasionally called—was noticeably preferred, but a shift in student activities came in 1907 with the completion of Alumni Hall (now called Enrollment Services Center). Located midway between the two

campus entrances, social gatherings, YMCA events and meetings were no longer on the north side of campus where campus residences were once centered. Alumni Hall also had a new dining hall called the College Inn. Off campus, L.D. Williams opened a general store on Hyland Avenue south of West Street around 1906. The Student Tailor Shop opened on West Street in 1908. Lewis F. Romans, a brief business partner of Henry Briley in 1905, and Frances M. Darner opened a grocery store around 1908 on Pike Street (Sheldon Avenue) down the street from Briley's. After Darner's exit from the business, Romans added the College View Restaurant before moving to 2508 Lincoln Way (now the Mr. Burrito building) as Romans' Refreshment Parlor a few years later. In 1909, Champlin and Ben Edwards began the Square Deal Coal Co., which would soon become the Edwards-Champlin Coal Co. until Champlin exited in 1914. Ben Edwards, who first arrived in Ames in 1905, rose to prominence as a city councilman and later as a state senator. His coal business—he later added ice for the summer months—located between Stanton and Lynn Avenues, had a monopoly on fueling West Ames residences and grew with the community.

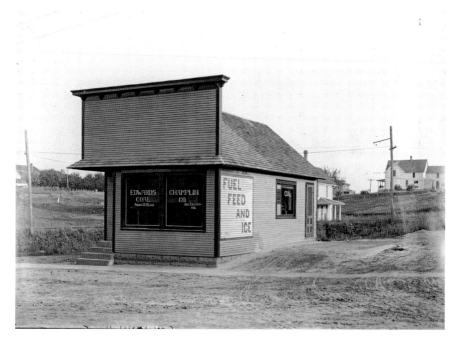

Located on Lincoln Way by the railroad, the Edwards Coal Co. would be the great fuel provider of West Ames. A.L. Champlin left the business in 1914. *Courtesy of George Bluhm.*

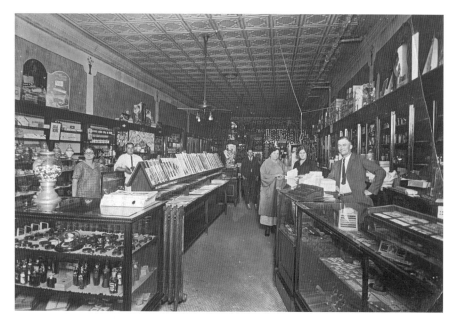

An inside look at Albert Louis "Lou" Champlin's Store in 1920. The store sold everything from film and paper to magazines and cosmetics. *Courtesy of George Bluhm.*

Ready for an expansion, Champlin built a new building on the corner lot in 1908. The fifty- by ninety-foot brick building had a basement for businesses, his general store on the main floor and a popular dance hall on the second foor that would also be an early church meeting place for local Presbyterians and Methodists. Completed in 1909, Champlin's new store soon advertised hardware, dry goods, a bakery and a drugstore. In the early years, the College Pantorium and Shining Parlor (and similar businesses) were in the basement, but the first staple was the Blue Bird Tea Room, which opened in 1915 and featured food "fresh from Champlin's farm."

In the following years, the West Gate neighborhood saw the most development. Frank Dixon opened a grocery store, Frank's Place, at the corner of West Street and Campus Avenue in 1911. It expanded to a two-story building two years later, selling groceries, candy, meats, fruits, vegetables, tobacco and bakery items. Also in the area, Annex Tailors and Cleaners, Annex Barber Shop and Lou Shull's Hyland Barber Shop all opened around 1913. Despite the growth, West Ames lacked a hotel, doctor, church, bank, movie theater and clothing store.

Campustown building still included several residences all during this time. More businesses didn't appear until 1914, when the Lincoln Highway came

through Ames. In April, Boone Street was renamed Lincoln Way until Pike Street (Sheldon Avenue). Pike Street was renamed North Lincoln Way, and so was Hyland Avenue from Oakland Street north to Ontario Street. Ridge Street was renamed Stanton Avenue around this time, too. In the following years, the College Pantorium (100 block of Sheldon Avenue), Banks' Garage and Marty's Place (on Lincoln Way) opened.

In early 1916, both Charles Barretta's new building at the corner of Lincoln Way and Welch Avenue (now home to Copyworks) and Carl L. Little and Edward E. Little's similar building (2504 Lincoln Way, now Café Beaudelaire) next door were constructed. The Orient ice cream parlor, operated by Lou Champlin's brother Howard, was the first to call the Barretta building home. Barretta, a popular barber, wanted a new home for his shop, but with the Orient in his building, he ended up renting space from the Little brothers, who were major real estate moguls at the time, in their new building. In February 1916, the brick College Savings Bank Building was completed at the southeast corner of Lincoln Way and Hayward Avenue, which was finally being extended over College Creek to Lincoln Way. Founded by its first president, C.J. Lynch, and originally incorporated for $25,000, College Savings Bank occupied the corner space. Annex Haberdashers and Tailors; Jameson's clothing store, a downtown

The College Savings Bank building, completed in 1916, was important because it included not only a bank but also a clothing store and supply store. *Farwell T. Brown Photographic Archive.*

store opening a location in Campustown; and Student Supply Store, which sold items like paper, cigars, magazines and candy and was a Campustown location for the downtown business Ames News Stand, were the other first occupants. The often-praised structure created the neighborhood's first business center. For many residents and students, it was a relief; West Ames finally had a bank and clothing store.

DRIVABLE STREETS, WALKABLE SIDEWALKS

Streets had often plagued West Ames. The student literary and news publication the *Aurora* stated that a flood created a hole eighty feet in diameter and thirty feet deep on Lincoln Way in June 1892. The Dinkey was a blessing, but it also had a soft monopoly on transporting people since even walking wasn't often advisable.

In 1899, the idea of extending Iowa Street (now Sixth Street) to the college was considered, but in March 1900, the *I.S.C. Student* stated that sidewalks and bike paths connecting the two sides of Squaw Creek were more critical. (In June, the newspaper noted that an automobile—perhaps the first—was spotted on the highway.) But in the spring of 1905, with the thaw underway, it seemed little had been done. "A town which if it would, could be as enterprising and as up-to-date as any town in the state. If the town didn't expect to install and maintain sidewalks in the college vicinity why is it that she was so anxious to annex it?" wrote the *I.S.C. Student* in February 1905. A year later, an ordinance that would fine people for spitting on sidewalks received this response: "Academic students now classified will probably have to wait until their third or fourth post-graduate year before they have an opportunity to violate this ordinance in College Addition to the city of Ames."

Some walks were laid during that summer and during the next few years, but these were west of campus near the engineering buildings and the already nice-looking West Gate entrance. In the summer of 1908, the Ames City Council finally passed a resolution that provided some acceptable sidewalks throughout West Ames, even though most of the resolution added sidewalks to the downtown area.

That same year, a new cement bridge on Lincoln Way was going to be built over Squaw Creek. The bridge felt the wrath of Mother Nature, and in June 1918, it collapsed, taking the Goddard family with it—don't worry,

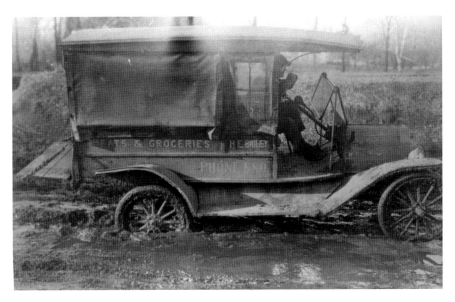

The H.E. Briley Groceries delivery truck in about 1916 makes the trip on the muddy roads somewhere in the Campustown vicinity. *Farwell T. Brown Photographic Archive.*

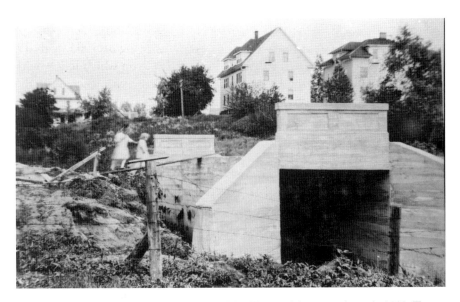

Some children play at the construction site of the Hayward Avenue culverts in 1918. Two years prior, culverts were established when the street was extended across College Creek. *Farwell T. Brown Photographic Archive.*

they were uninjured. A replacement wouldn't be built until 1921. Extending Sixth Street came up again in 1914, but the cost to build across the Squaw was too great. Campus roads generally improved in the early 1910s with some experimental grading, which only increased the poor-looking quality of the city streets. In 1915, the college agreed to share the cost to pave the adjacent portion of Lincoln Way, which for most of its existence had been a poorly maintained dirt and gravel road. "The road from Ames to the college campus is one of the worst stretches along the Lincoln Highway and that it will never be any better until it is paved," stated the *Ames Evening Times* in June 1915. The project was delayed, but Lincoln Way to the east was paved in the following years. It wasn't until 1921 that Lincoln Way adjacent to the college—from Riverside Drive on the other side of the Squaw to Olsanville Greenhouse—received a concrete paving.

Seen through newspapers, the disconnect between the two sides of Ames is evident in a piece from the *Ames Times* on August 31, 1905: "The fourth ward of Ames is making greater substantial growth than any other part and when the electric line is put in, which it will be inevitably, the fourth warders will have nothing to complain of."

From Dinkey to Streetcar

In February 1906, the Ames & College Railway was sold to the Fort Dodge, Des Moines & Southern Railway (FDDM&S). The old railroad line, which had become unpopular with students, was about to be part of a much larger route through Iowa. The new electric-powered interurban railroad came from the south and went through West Ames and campus and then east to downtown. Not ending service for the campus, a streetcar line was constructed that split from the interurban line near the ISU Power Plant and followed Osborn Drive on the north side of campus and then turned south to the Olsanville Greenhouse and continued south on Pike Street (Sheldon Avenue) to a West Gate station. In Campustown, the track was located between Welch and Stanton Avenues and began to curve to the east shortly before it reached what is now Chamberlain Street. It then cut diagonally across the terrain to the ISU Power Plant. The two mostly triangular buildings at the corner of Chamberlain and Stanton are a result of the era; the property lines were never straightened. And in general, property lines where the railroad was are anything but

straight and organized; a thin sliver of land between Welch and Stanton is still owned by the railroad.

The Dinkey was retired in September 1907, yet the new FDDM&S management stirred complaints within days. No regular schedule was created, which upset the students who lived downtown. And near downtown, the streetcars had to stop and wait for the main railroad—Chicago & North Western—to clear its many lines, which at times forced some students to wait a half hour. The cars were also crowded; more than fifty students refused to pay on one car when seats weren't available. The railroad finally added new cars to relieve the congestion. A cinder path was also constructed to make walking an option—and all this after only a month in operation.

During the next few years, complaints persisted. The only steady improvement was the railroad's power supply. However, the FDDM&S's upgrades and expansion throughout central Iowa put it in bankruptcy in 1910. The receivers were Homer Loring of Massachusetts and Ames banker Parley Sheldon, who would become mayor (for a third time) later that year. The frustrations could now be directed at someone. On February 6, 1912, the grievances manifested in an *I.S.C. Student* illustration: "Parley's Goat," a simple illustration of a goat with the FDDM&S letter on it. Why a goat? We

At the corner of Stanton Avenue and Chamberlain Street are two mostly triangular buildings separated by an alley. The alley is where the interurban track came through Campustown. *Author's collection.*

In 1913, the small West Gate station was across the street from the Sheldon Avenue and West Street intersection (later Collegiate Presbyterian Church). The railroad track was temporarily extended to carry building material. *Farwell T. Brown Photographic Archive.*

can only guess, but the usage points to a few reasons. The streetcars were often unattractive and didn't produce any positive results, which relates to the goat as an underwhelming dairy animal. The cars were always slow and didn't do as the residents desired, like an "old goat." For the next four years, the newspaper would occasionally refer to the train line as Parley's Goat, even after the company was sold in 1913. ("The 'Goat' Delayed by Sunday Night Storm," read a 1914 headline.)

After years of pondering, the FDDM&S built a loop around West Ames in 1916 once the residents had organized many of the details. The line that had ended at West Gate was extended south—hence the reason Sheldon Avenue was extended south of Lincoln Way—to Knapp Street and then east to the interurban line. It is at this time that Sheldon Avenue got its name. The Fourth Ward Civic Improvement Society requested that the street be named after the former mayor (I guess not everyone was bitter toward him). The loop was a welcomed addition because State Field (later Clyde Williams Field, located where Martin and Eaton Halls are) had been recently completed, and the neighborhood south of Campustown was growing quite quickly. There was also a lot of growth farther west of campus as building began to push well beyond Howard Avenue, as well as development along Wood and Arbor Streets.

The First School

Before West Ames was annexed in 1893, a one-room schoolhouse existed to serve the children of the area. Located on the north side where West and Woodland Streets meet, the Fox Schoolhouse goes back to at least the early 1880s. Not too much is known about the school, and only one source, a history of the Friends Church in Ames, listed a name. A few teachers are mentioned in the newspaper when they began teaching at the school (Lizzie Little in 1892, Kittie Freed in 1894 and Pearl Gretsiuger in 1902), and there's a story about how children would slide down the nearby hill on barrel staves—a predecessor to skis, let's suppose. It also served as the first home for the Friends Church (see chapter 5), as well as a meeting location for various groups.

In June 1903, a special election was approaching that would OK the Ames School Board to build a new school north of downtown. West Ames residents had a different idea, and forty-five eligible voters petitioned the Ames School Board for one to be built near Iowa State. The Fox Schoolhouse was the property of the Washington Township School District and was put up for a public auction in July. At this time, West Ames students (70 total, with 14 in high school) traveled via the Dinkey—the school district had an agreement for discount students' fare—to the downtown schools, which handled 640 other students, too. The support from West Ames residents, who were concerned that a school might not be able to keep up with the downtown schools, wasn't strong enough to earn a place in the election.

The issue reappeared in September 1905 as the number of first, second and third graders had increased enough to warrant a new school being built. On March 12, 1906, residents overwhelmingly voted—257 to 14—to issue $9,000 of bonds to build a four-room school in West Ames. The number of students had doubled to 140 in less than three years, and the expense of transporting students was adding up for the school board. Many students were traveling nearly a mile just to reach the motor station on Central Campus. Welch School, an elementary and junior high school located at 120 South Hyland Avenue (now apartments), was not finished in time for the school year. First through third graders met at the Friends Church, and the other grades met at the high school. In January 1907, with an enrollment of 96 students, Welch School opened with teachers Mary L. Ervin (also the principal), Lillian Simmons and Florence Brennenman. The building also housed a library and principal's office.

Harlan School, 120 South Hyland, was razed in 1977. Originally known as Welch School, it opened in 1907 as the first school for West Ames. *Farwell T. Brown Photographic Archive.*

After opening, a problem arose for parents of the area's thirty-five high school students. With an expired contract, the new railroad owners, the FDDM&S, wouldn't provide any reduced fare for the teenagers, so with students making the trip four times a day—to and from in the morning and the afternoon—there was a sudden burden of twenty cents a day (forty dollars for a full school year). As the fall 1907 school year approached, Superintendent Welty refused to provide a fare since the school board was under no obligation to do so. The state superintendent upheld the decision. It was either walk or pay, and while sidewalks were completed on Lincoln Way to connect both sides of the Squaw, they weren't impressive. There was also the danger of having to cross several railroad tracks south of downtown.

CITY UTILITIES, PLEASE

West Ames was frequently the last place to receive services such as electricity and sewers, and even then it was piecemeal. Being on the other side of Squaw Creek, which frequently flooded, regularly impeded the results. Iowa State's

first electric lights were turned on in 1884, and the insides of buildings were lit by the end of the century. The West Gate neighborhood received lights in December 1902 when Iowa State agreed to light the street. Electricity slowly trickled out in the following years.

Thanks to Anson Marston, dean of the division of engineering at Iowa State and designer of the school's sewer system, the first notable steps for a sewer system were established in 1906, when the city reached an agreement to connect residents to the college disposal plant. That same year, the city hired its first city engineer, Thomas H. MacDonald, replacing Marston, who was a consultant. In 1907, the sewage conditions were apparent and posed a hazard to the public's health. Many of the large houses collected sewage in shallow pools that overflowed into drains that connected to College Creek, which frequently was used as a dump—a problem that still lingers today. Thankfully, the creek was in a constant flow. However, much of the district's water was coming from shallow wells that were under constant threat of contamination. Pockets of typhoid fever and cholera occasionally emerged in West Ames throughout the early and mid-1900s. In 1905, outhouses were required to connect to sanitary sewer systems, but in West Ames, there wasn't any enforcement. Ordinances of various sorts regulated the city sanitation system, but those lines were mostly absent in West Ames. As late as 1909, some residences on Hyland Avenue still used open sewers next to their property.

In 1908, water and sewer systems were again on the city's agenda, and in May, voters approved issuing $15,000 in bonds to build a water system in West Ames. Though still moving forward, the work of Iowa State's sanitary committee was overshadowed by a report from Marston to President Albert Storms that expressed disdain and shock at the appalling sanitary conditions throughout West Ames and stated that if there was an outbreak, the city and college would share blame because they knew it existed. In 1906, the Colonnades clubhouse, the building once home to Hawley Miller's store at Lincoln Way and Ash Avenue and now owned by Albert Louis Champlin, was the site of a terrible typhoid outbreak, and inspectors believed it was because of a contaminated well. Since the city had lax enforcement of the municipal sanitary ordinance in West Ames, Champlin had ignored requests by the city to improve his property. Storms took action and made sure the city enforced the rules by bringing in the State Board of Health. In September 1909, the city finally forced residents to connect to the city's sanitary sewer, and enforcement of health ordinances improved.

Water mains were laid in piecemeal throughout the area and connected to Iowa State's water supply until World War I, when the project was put on hold. By 1918, parts of West Ames were on the same large municipal grid as the rest of Ames, but connecting all of West Ames still took several more years. It wasn't until 1922—more than twenty years after the first projects— that the city was operating as one grid and no longer dependent on Iowa State's utilities.

Other city services that were mostly absent included fire and police protection. The Fourth Ward Fire Company was formed in January 1910. A couple years later, a firehouse was built at the corner of Lincoln Way and Sheldon Avenue. A small fire at the Pi Beta Phi sorority (then at 129 Ash Avenue) in 1912 was noted because had it been greater, stopping it would be difficult because Ash Avenue's only fire hydrant was more than two blocks away, at Knapp Street. A regular police presence wouldn't occur until 1915, when two officers were put on duty, one paid by the city and one paid by Iowa State.

THE CITY OF WEST AMES

Reading about West Ames's struggles to grow, it's not hard to see why the residents were upset. Constructing public utilities was always going to be an uphill climb, but with bad sidewalks, lackluster streets and horrible train service, among other things, a secession movement had been in the works for years. In 1914, the movement gained traction, but the first mention of secession appeared in the *I.S.C. Student* on February 6, 1912. "Ames is on the verge of a municipal rebellion," read the first sentence. "More Hydrants" was the slogan, and the article noted that the Pi Beta Phi fire was one of four recent fires, including one at Welch School, that were amplified because of slow water access, causing losses that shouldn't have occurred. These secessionists are only identified as "residents at the college," and despite them wanting some action on an upcoming election ballot, nothing was mentioned again.

On October 19, 1914, fifty men, most Iowa State faculty members, met to air their grievances and take action because they had lost confidence in the city's ability to fix their continuing problems. The men were disgusted with the streetcar service, hotel accommodations and roads to and around the college. Thomas R. Agg, assistant professor of engineering, was elected

chairman. Those selected to lead committees were Warren H. Meeker, head of mechanical engineering; Thomas H. MacDonald, the former city engineer and now state highway engineer; and Charles H. Stange, dean of veterinary medicine. The men were most upset by the Fort Dodge, Des Moines & Southern Railroad's often late service—its franchise stated service every twenty minutes—and they didn't want to listen to representatives of the company because they had heard enough broken promises; the same went for Mayor Parley Sheldon and the city councilmen. Seceding from Ames and incorporating as West Ames was also discussed, but the importance of incorporation differs by newspaper. The *Ames Tribune* emphasized the idea—"Threaten to Incorporate Town of West Ames," read the headline—while the *I.S.C. Student* downplayed it, stating that, if deemed necessary, it would happen, but such discussion didn't dominate the meeting. The *Ames Evening Times* was somewhere in the middle. However, a week later, members backtracked the thought of seceding from Ames, and the second meeting was a quiet, educational gathering where attendees heard reports. The group remained intact and seriously explored ways to fix its problems, but the thought of incorporation vanished.

During the next two years, West Ames made real progress: the Lincoln Highway came into existence, the College Savings Bank opened, Collegiate Presbyterian was being built, Collegiate United Methodist Church was founded, Hayward Avenue was extended to Lincoln Way, a loop was established around West Ames for streetcar service, telephone lines were upgraded and a few taxi services (College Taxi Co., Ames Taxicab Co., Fourth Ward Taxi Co.) began operation. But across the Squaw, Ames built a new city hall, Mary Greeley Hospital opened, the Sheldon-Munn Hotel opened and several downtown streets were paved.

On August 12, 1916, five petitions began circulating around West Ames supporting a severance from the city of Ames with the names Champlin, Francis J. Moravets, Elroy W. Kimble, Albert T. Lerdall and Ralph L. Brooks leading the process. Newspapers state the petition's reception was positive, but the conundrum that a new city would have to build its own school, among other things, was off-putting to some residents. Iowa State president Raymond Pearson was said to be openly against the action. We can only speculate about the reasoning behind people's actions now, but an obvious reason Champlin and others would want to sever from Ames was the grasp Iowa State had on West Ames. Champlin was the Campustown entrepreneur, but in 1916, college administrators wrote an ordinance forbidding movie theaters in West Ames (see chapter 4). Pool halls and

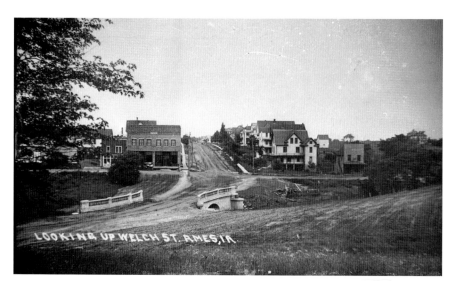

Looking up Welch Avenue from campus, Champlin's store, completed in 1909, is on the left, and the Zimmerman House, which burned in 1910, is on the right. *Farwell T. Brown Photographic Archive.*

bowling alleys were also forbidden. Iowa State's in loco parentis (in place of a parent) policy often trumped business interests, especially when it came to matters of property near the college. Perhaps Champlin and the rest were seeking to incite unrest. Moravets was a city councilman, Lerdall was one of the top real estate agents in Campustown and Brooks was a founding College Savings Bank employee.

Within a couple months, 134 residents had signed the petition. A large meeting on October 10 attempted to put the secession crowd at ease even though the petition leaders refused the invitation. Tax spending, schools, outstanding bonds and past neglect were aired at length, and a week later, another meeting took place at Welch School with even better results for the city. West Ames residents were being talked off the ledge, as the severance leaders didn't join the discussion. Residents were told Welch School cost more than taxes collected and West Ames's development was still too scattered to support large-scale street paving. A committee was appointed to collect grievances. The demands included better street crossings, better police and fire protection, a city manager form of government, paved streets near Iowa State, school-paid transportation for high school students, amusements (aka movie theaters) be allowed but regulated by a local group and building permits be required. About half of the signers requested their names be removed from the severance petition.

On October 20, the petition was filed, and notice was served for West Ames's severance from the city. The first court hearing was in January 1917 and was an early win for the city, which filed a demurrer that a majority of people in West Ames had not signed the petition, making it insufficient. Five dates for trial notices appear over the next few years, with the case ultimately being dismissed on March 31, 1920. The secession was over before it reached a courtroom, but the resentment was real. If the city had sat on the sidelines, severance could have happened, but seeing how quickly the movement was appeased and lack of engagement from the petition leaders, who were local leaders, you must question their intentions.

CHAPTER 4

BETWEEN TWO WARS

In the immediate years following Beardshear's Addition and Parker's Addition, several more plats were established to the west and south of Campustown. Lee and Little's Addition in 1903 pushed Welch Avenue to Storm Street (and, like Beardshear's, made no consideration for any street to be extended east). Clark's Addition, Resler & Miller's Addition and Lee's 2nd Addition created the neighborhoods surrounding Campustown, but it wasn't until after World War I that they began to blossom with new homes. After World War I, the residents of Campustown awaited action from the city from its promises made to calm the secession movement. The growth of West Ames was much more pronounced in the 1920s, making it too big to ignore. An annexation in 1924 extended the city limits to the west of Franklin Avenue, and many streets were being paved.

The Roaring Twenties were good for Iowa State, which climbed from 3,584 to 4,318 students. New women's dormitories were built in the 1910s, but men's dormitories were limited to Hughes Hall, built in 1923. Men had long complained about the lack of living quarters near campus and the forced life of commuting that was thrust on them as soon as they arrived in Ames. The *Ames Tribune* stated in 1921 that despite about 120 homes being built before the fall, at least another 100 apartments were needed to accommodate all the students. By the end of the decade, most of the building was still happening in West Ames, not "Big Ames." The West Ames Business Men's association was formed at some point in the late 1920s, too. Led by Albert Louis Champlin, the association lasted for a few years but only

met in the case of a crisis—no meetings are recorded. The Campustown commercial center was never landlocked, but any expansion, especially along Welch Avenue, was going to share land with residences. Before World War I, you saw a few downtown shops launch satellite shops in Campustown. In the following years, Tilden's department store; the Fair; Gus Martin clothing store; Ames Service Store, a grocery; and Dudgeon jewelers followed. In 1931, Charles R. Quade moved to Welch Avenue after thirty-five years as a photographer on Main Street. He was the first occupant of 109 Welch Avenue (now Mickey's Irish Pub). Quade moved back to Main Street the following year, but the location remained a photography studio—notably College Town Studio—until the mid-1960s.

As the city quickly spouted following the war, a city plan for orderly development was deemed necessary. A zoning commission was formed in 1924, which included Campustown businessmen Charles Ash, one of the founders of College Savings Bank, and Champlin. In 1930, the Ames City Council passed its first zoning ordinance. It zoned the center of Campustown (roughly from Hayward to Lynn Avenues and just over one block to the south) as D District (business and light industry). It was definitely a liberal decision—arguably, even unfounded—because south of Lincoln Way, there was little commercial presence, including on Welch Avenue. The rest of Campustown (as well as the land surrounding Iowa State) was designated B District (residential) for multiple-family dwellings. Already, city planners were envisioning the necessary expansion of larger dwellings for students in the future. Like today, Knapp Street was the primary dividing line. South of the street, with a few exceptions for fraternity houses and boardinghouses already built, was zoned for single-family dwellings. One thing missing from this was any municipal land for public recreation. Mostly likely, the Iowa State campus across the street with its open space and meeting rooms deemed a public space in Campustown unnecessary.

Ames in general did OK during the Great Depression. Times weren't always good and not every business survived the 1930s, but compared to the rest of the country, Ames did quite well. There are frequent references to college students who didn't return to campus because of bad financial situations at home, and some Greek houses didn't survive (see chapter 6). Iowa State saw an enrollment decline in 1932 and 1933, but by the fall of 1940, enrollment was up more than 50 percent compared to a decade earlier. By the mid-1930s, Lincoln Way had grocers, beauty salons, men's and women's clothing stores, jewelers, dentists, doctors, barbers, cafés, a movie theater, bookstores, restaurants, bakeries, shoe stores, insurance

This 1938 aerial shot shows both Campustown and the college campus. Lake LaVerne and the Memorial Union are at the center. The railroad still cuts through Campustown. *Courtesy of Memorial Lutheran Church.*

agents and a hardware store. Off Lincoln Way, you could find more: a shoe repair, groceries, photographers, a plumber, dry cleaners, beauty salons, barbers and a printer—most confined to Hayward and Welch Avenues. Downtown remained a force for specialty shops, but the necessity to go there or Des Moines had vanished. By the end of the 1930s, Campustown was a dominant force in business.

WORLD WAR I AND FLU PANDEMIC

The international cloud looming over the post–secession era developments was the war in Europe. Building projects in West Ames in 1916 were as strong as ever, but after the country went to war in April 1917, just about everything hit the pause button. Some Greek and clubhouses, many of which

were migrating to the Campustown vicinity, were left unfinished because the materials were needed for the war effort, and several fraternities were converted to barracks. Work on utilities ceased because costs soared.

However, in the final months of World War I, it wasn't the war that was making headlines; it was the 1918 influenza pandemic. The first cases on campus began to appear in October 1918, and within just a few days, a quarantine was issued. The Iowa State campus was under a closed quarantine, meaning no one got in or out without an OK from the Student Army Training Corps (SATC) headquarters. The rest of West Ames was under a limited quarantine. Auto travel was mostly restricted to Lincoln Highway, and different passes were required for people to travel to campus, West Ames and downtown. Of the 119 people of Iowa State who died serving during World War I, 51 died from the flu.

There was a business casualty during the flu pandemic. Marty's, at 2520 Lincoln Way, was a favorite restaurant for students, especially for an evening snack after a night of dancing at Champlin's Hall. Marty had worked at the spot, formerly known as the Bean Wagon, for about four years, and in 1917, he moved into the new location. In 1918, the military authorities at Iowa State closed the restaurant, citing unsanitary conditions such as stacks of dirty dishes sitting in sink water that had a layer of grease at the bottom. Marty told a different tale. He said the place was closed because he shut the door on two military police officers who demanded service after he and his wife had closed up for the night. Those two swore they'd get even, and two days later, his restaurant was shut down. Marty, who was battling influenza at the time, sold the place and vowed never to do business in the area again.

The Long Road to a Movie Theater

Downtown Ames had three movie theaters by the mid-1910s: the Twin Star, which opened in 1907 as the Scenic; the Princess Theater, which opened in 1911; and the Palm Theater, which opened in 1914. The movies were big business, always drawing a crowd from both residents and students. Nevertheless, movies theaters were discouraged near the college by some faculty and administrators because they believed students must devote their time to study and not be tempted by such establishments.

The first attempt to construct a movie theater in West Ames was brief and unsuccessful. In 1914, after the closing of the Friends Church (see

chapter 5), Agnes Cole was seeking a new operation for her property on the northwest corner of Lincoln Way and Sheldon Avenue. She, an alumnae of Iowa State, was approached about opening a movie theater, but Iowa State vice-president Edgar Stanton persuaded her to refuse the offer. Cole was one of the people who believed movie theaters had no place in a college community.

During the construction of the Athletic Drug Co. on West Street in June 1915, owner Samuel V. Whittaker, of Ottumwa, wanted to build a movie theater next to his forthcoming drugstore. When he submitted his proposal to the city council, he already had an offer for someone to operate it, and accounts state the theater was favored by many people in West Ames. Iowa State administrators did not favor it. Yet Iowa State wasn't anti-movies; quite the opposite. The YMCA, which was housed in Alumni Hall (now Enrollment Services Center), first showed a movie on campus in 1913, and Sigma Chi, the honorary journalism fraternity, did the same in 1916. Some departments of Iowa State's Extension branch began producing features pertaining to their work and research. Iowa State entered the business in 1915 with the other state schools, aiming to make films featuring the school, lectures and research. Various student clubs occasionally played movies about their professions, too. Iowa State administrators were against the subject matter, not the medium. They knew the power the movies could have on building the school's reputation and shining a new light on the research being done. At the city council meeting on June 21, the council rejected the proposal for Whittaker's movie theater, and no building permit was granted.

In April 1916, Champlin had plans to build a seven-hundred-seat, $25,000 movie theater next to his corner brick store that would open by the fall, including another dance hall for Campustown decorated in cardinal and gold. Joe Gerbracht, who owned the Twin Star with his sisters, Della and Ada, would lease the theater. Not to be outdone, another movie theater was announced days later for the West Gate neighborhood. To be located on North Lincoln Way (Sheldon Avenue), the theater would be leased by William A. Matlack and John E. Foley, managers of the Princess Theater. But during these events, the Ames City Council was attempting to pass an ordinance that would forbid movie theaters in West Ames. Petitions opposed to the proposed ordinance were circulated, and Gerbracht was ready to take the city to court.

On May 22, locals gathered for a heated meeting at Champlin's Hall. Perhaps Champlin, who organized the meeting, thought the meeting would be a show of strength against Iowa State policy. Stanton said movies were

as dangerous to students as pool halls and saloons, and they took students away from their weekday studies. He believed movies were a gateway to wanting dances and banquets any day of the week—the horror!—and not only students but also the school (and its reputation) would be better off if there were no movie theaters in Ames. Most others in the room were pro-theater, even if it meant putting a temptation at students' doorstep. Students would face many temptations in life, so why shelter them and deny the local residents an entertainment option that businessmen want to construct? The proposed ordinance died in its second reading because there were only four members present, with three voting in favor of it— not enough votes to be legitimate.

Much to the dismay of West Ames residents, an ordinance was approved later in the year, and movie theaters were restricted to Main and Fifth Streets between Duff and Grand Avenues. The ordinance didn't have a long life, as theater interests in the area only increased in the following years. In July 1919, with a repeal of the ordinance on the horizon, Iowa State president Raymond Pearson wrote to Ames mayor Edwin H. Graves: "We would deeply regret [having] moving picture shows established in the fourth ward." Iowa State administrators didn't have enough muscle, and

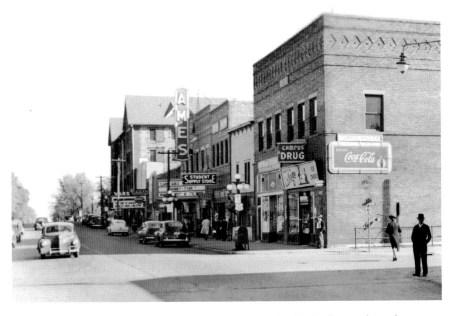

In 1941, the Champlin building is seen at the corner, with other businesses down the street, including Student Supply Store, Ames Theater, College Inn, L-Way Café and Varsity Theater. *Ames Historical Society.*

on August 5, the ordinance was repealed. The following day, a contract was approved for Champlin to build a theater building that Matlack would manage. On December 29, the eight-hundred-seat American Theatre opened with director Cecil B. DeMille's *Male and Female*, starring Gloria Swanson. The name was short-lived, as Matlack sold his operations to the A.H. Blank Company of Des Moines a few months later. At the same time, Gerbracht started a relationship with the Blank Company, and he took over the management of the theater, which was renamed the Ames Theater in September; the theater was closed during that summer. Gerbracht was now the movie theater magnate of Ames, controlling all of them (Twin Star, Princess, Ames). A remodeling of the Ames Theater in 1928 not only readied the theater to play sound movies but also increased its seating by adding a balcony. It was renamed the New Ames Theater.

THE MOVIE THEATER SAGA CONTINUES

As the Campustown theater ordeal played out in 1919, another movie theater concern arose: indecency on the screen. After a few shocking promotions, questionable movies and live acts that more than raised a few eyebrows, the city established a board of censors. It made a few headlines, but its overall effect doesn't seem too large because it vanished rather quickly.

Sunday movie shows weren't legal to play in Ames until 1917, when Iowa law changed to make it a local matter for cities with a population of five thousand or more, but as public debate about it continually came up, the city council called for a referendum in April 1922 to forbid Sunday movies. Despite a lot of support for Sunday movies, the nays won—1,652 to 1,137. Joe Gerbracht spent $2,250 on court costs trying to fight the proposals. The issue continued to pop up every so often during the next six years, when again the city council put the issue to a referendum. The nays won again, but only by 36 votes—2,043 to 2,007. This was a vigorous public debate, and the council found it had to take action. The downtown wards (first, second and third) had voted in favor of Sunday movies, while the Fourth Ward (Campustown and the rest of West Ames) voted against Sunday movies, so the councilmen from the downtown wards suggested to allow Sunday movies at the downtown movie theaters. The proposal still split the community. If the Campustown theater couldn't show Sunday movies but downtown could, Campustown was getting special

treatment that plainly didn't serve the residents and treated the area differently than the rest of Ames. Church leaders even disagreed on the issue. Downtown church leaders believed Iowa State's presence warranted the special treatment, while Campustown church leaders wanted the ban on all Ames theaters. On July 28, 1928, the city council passed the ordinance only allowing Sunday movies downtown. The one councilman to vote against it was the representative of the Fourth Ward. Five years later, the ordinance was amended and Sunday movies were allowed. At that time, only two other Iowa towns—Pella and Forest City—forbid Sunday movies.

Demand for a second movie theater in Campustown popped up occasionally during the 1920s and 1930s, and local opinion certainly would have appreciated another theater. In 1936, and continuing for the next couple years, there was outside interest in opening a movie theater somewhere in West Ames. With little known about it, possible plans and how serious they became are now gone, but it must have lit a spark. In 1938, Gerbracht and Champlin built the Varsity Theater just a few doors down from the New Ames Theater. If there are two places that people have in common during their time at Iowa State and/or in Campustown, it's going to the movies at the Ames and Varsity Theaters. The Ames Theater closed in 1996 when the Varsity was split into a two-screen theater.

Campustown Picks Its Name

In Campustown's early years, people might have referred to it as Dogtown, South Gate, Southside and even Champlinville. In West Ames's early days, South Gate referred to the campus entrance at the Knoll, but in later years, South Gate often referred to the Welch Avenue entrance, especially after a new bridge was built in 1911 (a bit of it can still be seen today). For those in West Ames, Southside was a reference to Campustown since there was also a Southside of east Ames. Champlinville was also a nickname given to the area and serves as an example of Champlin's influence. Dogtown was a name often used but only verbally by the citizens. The meaning behind it isn't clear, as there are varying tales. One story states that before cars, students had to "dog-it," or walk, everywhere if they wanted something. Another story states people observed that the buildings were reminiscent of prairie dogs—a lot of buildings but nothing very tall. An extended part

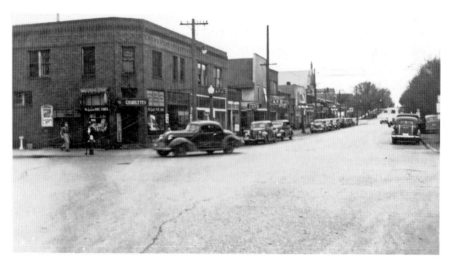

Looking west on Lincoln Way, you can see the McGuire Pipe Shop on the corner. In 1946, it became the College Pipe Shop and was run for decades by John Stuckey. *Ames Historical Society.*

to the story (or another version to some) states that the neighborhood was also a rough place to live. Lastly, back in the early days, there were several dogs running about the neighborhood—including the Champlin family dog, Sport—and they'd travel the neighborhood, visiting shops. Dog packs were a pretty common sight, evidently.

The business environment in Campustown was blossoming nicely as it entered the Roaring Twenties. Champlin had his flourishing grocery and pharmacy business (he retired from it in 1923). By 1922, there was a movie theater (Ames Theater), candy shops (Fontanelle, Lincoln Candy Kitchen), grocers (A.L. Champlin, Beman's Grocery), shoe stores (Trueblood College Shoe Store, Campus Electric Shoe Shop), cafés (Campus Lunch, Blue Bird Café, Virginia's), barbershops (Midway Barber Shop, Lincoln Barber Shop), clothing stores (Jameson's, Campus Toggery), a garage (Champlin Garage), supplies (Student Supply Store), fuel (Edwards Coal Co.), a novelty store (Varsity Shop) and a bank (College Savings Bank). Even though it was on the Lincoln Highway—there was minuscule commercial development off Lincoln Way—it was a community dependent on foot travel. Yet the business owners didn't have a good advertising campaign to distinguish themselves. They needed a brand, to view it from a modern standpoint, or at least a name that could stick. There were a few attempts—"The Way," "The Street"—to emphasize the redundancy of going downtown to shop, but it wasn't enough.

Seeking a suitable title to label their district, local merchants held a contest to name the district in 1922. In the April 7 edition of Ames's newspapers, the winning name was announced: "Campustown." The prize of twenty-five dollars went to Ford K. Edwards, a freshman in electrical engineering, and John N. Thurber, an Ames High School student and son of an English professor at Iowa State. With two winners, the prize money had to be split two ways. Thurber, who later attended Iowa State, would become a well-respected labor economist.

Within days, Trueblood Shoe Store, 2544 Lincoln Way (now part of US Bank), had embraced the new name in its advertising. It took a few months for newspapers and other businesses to widely adopt the name. However, students who went to Iowa State as late as the 1960s still referred to the district as Dogtown.

The Female Faculty Build a Home

In 1907, the Sanitary Building, formerly the college hospital and located near the current site of the Memorial Union, was briefly known as Cranford Hall. It served as a faculty club for female teachers. The reason for the name Cranford remains uncertain, but in early 1909, the PEO Sisterhood, an international women's organization, announced it would present the play *Cranford*, which is about the lives of a few women in the small town of Cranford. As the home economics program at Iowa State grew, so did the faculty and the need for faculty housing. Finding such housing was difficult because of lack of finances and discrimination by lending institutions, and Iowa State didn't provide much housing for students, much less its faculty. In April 1922, some women joined together and created the Faculty Women's Housing Company, determined to build a multi-family residence. Maria Roberts, dean of the junior college, was vice-president of the company, and Julie (Wentch) Stanton, Edgar Stanton's second wife, was secretary. The building was designed by Iowa State alumnae Alda Wilson, who also oversaw the construction. The company incorporated at $100,000 and financed its new residence by selling stock. The first floor would have retail space.

Later that year, the $110,000, four-story Cranford Apartment Building was completed at the southwest corner of Lincoln Way and Stanton Avenue and was an instant success, with many units taken before completion. Between fifty and sixty women could call the building home at one time.

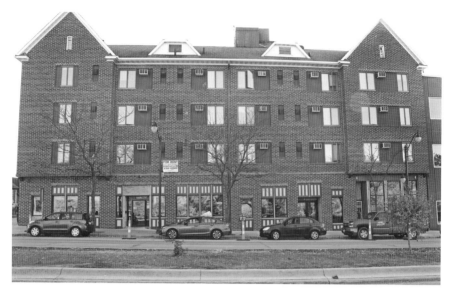

The Cranford Building, located at the corner of Stanton Avenue and Lincoln Way, was built in 1922 as a home for the single women faculty at Iowa State. *Courtesy of Marilyn Alger.*

Roberts, a mathematician and beloved faculty member by the students, lived in apartment 21 until her death in 1942. One of the ties between Roberts and Wilson was they were members of the Pi Beta Phi sorority. Other women who lived at the Cranford were women's suffrage leader Carrie Chapman Catt, who was also a member of Pi Beta Phi; conservationist Ada Hayden; home economics dean Anne E. Richardson; mathematician Anna Helen Tappan; and professor of mathematics Gertrude Herr.

The first businesses in the new building were the Cranford Beauty Shop, which would remain in the building with different names and owners until the early 1990s; Cranford Coffee Shop; the Varsity Boot Shop; and a branch of the popular downtown clothing store the Fair. Other early businesses included Wilson-Lindquist Cleaners and Tailors, which opened in 1929, a year before constructing a building on Hayward Avenue (a bit more on this later in the chapter). The Lincoln Way Pharmacy opened in November 1925 and would go through many names—Spriggs, Landsberg, Klufas—through its sixty years. The women's clothing store Bobby Rogers first took root in the late 1930s and remained until the early 1980s, and a jewelry store—Parno Jewelry at first, then Schafers and finally Bates—remained through the 1960s. The building was also home to some of Campustown's first doctors (A. Ritan, Benjamin Dyer,

Harry Johnston) and dentists (K.R. Ferguson, Howard Pollock, Keith McNurlen).

The building was later owned by Robert E. Buchanan, an Iowa State dean, and his wife, Estelle. In 1969, it was passed to their son Joseph, a lawyer who had an office in the building from the 1930s to the late 1960s, and months later it was sold to Cranford Apartments, a co-partnership between five men: Earl Gibbs, Eugene Harris, Edwin Hutchins, Milton Seiser and Rudy Van Drie. Gibbs's son and daughter, Monte Gibbs and Marilyn Alger, currently own the building. With help from a city grant, the building's façade was improved in 2015.

HALTING BUSINESS EXPANSION

In the fall of 1923, Robert and Hattie McCarthy, the platters of the original Campustown blueprint, Beardshear's Addition, began construction for a new cleaners on the west side of Ash Avenue just south of Lincoln Way. In November, with not much more than a hole dug, the State Board of Education (now the Iowa Board of Regents) secured a temporary injunction to stop work and a legal battle was about to begin.

In the fall of 1915, not long after the Lincoln Highway was created, businesses started to spring up on Lincoln Way near Welch Avenue. Iowa State administrators were concerned businesses would continue expanding to the east along the street and ruin the landscape that greeted visitors with storefronts. The only commercial building in this two-block stretch of Lincoln Way at the time was the Edwards Coal and Ice Co. at 2312 Lincoln Way (now apartments). President Raymond Pearson, acting on the authority of the State Board of Education, approached the landowners of the lots on and near Lincoln Way between Lynn and Ash Avenues with a proposition: if the landowners agreed to build at least thirty feet back from side streets (Ash and Lynn) and forty feet from Lincoln Way and prohibit any commercial usage, Iowa State would construct a new campus entrance near the interurban crossing at Lynn and create a new beauty spot by building an artificial lake with College Creek as the source. While the Lynn Avenue entrance was built, the McCarthys argued Iowa State had failed its end of the deal because Lake LaVerne, completed in December 1916, was "a mosquito and malaria breeding place, covered by green scum, etc.," and not maintained. The young lake didn't have a good reputation, often covered in

moss and nicknamed "Lake LaMud" and "Ponda LaMud" by students, but the agreement between the landowners and Iowa State only specified the dimensions of a lake. Only one landowner, John E. Brindley, would sign a testimony from Iowa State stating it would hold up its end of the agreement. Though sympathetic to the school's position, A.L. Champlin wouldn't sign, and David M. Ghrist "refused to sign anything."

With the narrow interpretation, the court ruled in favor of Iowa State, and despite trying to improve LaVerne's reputation with testimonies, the school's reputation was a bit stained from newspaper headlines. However, Pearson was already putting money together to improve LaVerne's upkeep. Ames's first zoning ordinance was in the works, and it would stifle administrators' concerns about the growing commercial district. A few businesses appeared near Lincoln Way and Lynn Avenue off the railroad tracks, but most of the area was populated by churches and Greek houses. Pearson approached the landowners from Ash to Beach Avenues in 1919 requesting an agreement with much of the same specifications as in 1916. However, there was no lake or campus entrance in return. Instead, the college would do the same—not build too close to the road. All the landowners, many Greek houses by this time, agreed.

THE MEMORIAL UNION ARRIVES

Before World War I ended, there was discussion of what kind of memorial should be built for those who died while serving. Iowa State was slow in getting the project off the ground because for years there was a debate about what should be built—fountain, sculpture, park, gateway, building—even though money was pledged. An agricultural recession in 1920, the same year the Memorial Union concept was determined, slowed fundraising since it affected many alumni, and they were going to have to be big contributors to make the project possible. The site of the Union was selected in April 1925, and construction began in 1927. The school's housing shift to the south—that began with the completion of Alumni Hall (now Enrollment Services Center) in 1907—had become apparent in the years prior. Lyon and Freeman Halls were built before World War I, and Birch Hall was occupied in 1923. Hughes Hall, which is now the western piece of Friley Hall and the dormitory for men since Old Main burned down a quarter century earlier, was completed during construction on the Union. Welch

Hall would be constructed by the end of the decade. Alumni Hall was at the center between the West Gate entrance and the entry from Welch Avenue, but the Memorial Union was at the center of the two upcoming residential centers—women lived on the east side; men lived on the west. The Union quickly became a hub of student and alumni activities and conferences.

When the Union opened in September 1928, it included a cafeteria and a barber and beauty shop, much to the chagrin of Campustown proprietors. The businessmen had made contributions to help make the Memorial Union possible, and some felt a bit betrayed with businesses in the union. They were funding something that could be their own demise. As told by Lynn Lloyd, granddaughter of Champlin, the story goes that Champlin marched to the Memorial Union to ask why businesses were allowed. After all, Iowa State played its part in providing an education and some housing while Campustown was there to fulfill the needs of the students. Champlin pulled his funding of the Union, and other local businessmen followed his lead. The barber and beauty shop remained a fixture through the MU's first decades.

From Trains to Buses

West Ames was entering a new transportation age. Taxi services had long been in the Campustown vicinity, but the new transportation in the 1920s was the bus—unregulated and a big competitor to the streetcar from the beginning. Buses were prohibited from operating on streets that were served by streetcars—its earliest regulation—but feeling the competition, FDDM&S Transportation Company (new ventures, new name), began a bus service of its own for Boone-Ames–Des Moines travelers in 1924. After twelve years of service, the Fort Dodge, Des Moines & Southern's streetcar service was at an end in 1928. The latter addition of the college loop—West Street station south on Sheldon Avenue and then east on Knapp Street to the interurban line—was abandoned in the summer. The tracks were removed, too, but a small piece of track was kept at the Knapp Street intersection so the streetcar could turn around. The following year was the last one for streetcar service in West Ames. In the summer, the FDDM&S was granted a request to stop its service during the summer months. It never resumed. In August 1930, the streetcar tracks were removed. Heading west through Campustown, a longtime bus route was Lincoln Way until Lynn Avenue, where it turned

Here's one of the Midwest Transit Line Company's buses from the mid-1940s. The company became the primary operator of buses in Ames in the 1930s. *Farwell T. Brown Photographic Archive.*

south until Knapp Street. It continued west on Knapp Street until turning north on Welch Avenue. It then continued west on Lincoln Way. As the city grew, bus routes changed and other routes would be created, but satisfying the residents' needs was always a struggle for the bus system.

BANK ROBBERY, BUILDING AND BEER DURING THE DEPRESSION

In 1919, Henning "Henry" Lindquist, a Swedish immigrant, arrived in Ames. A tailor, Lindquist had three brothers—all were tailors—and likely joined the two who were in Ames in their cleaning and tailoring business, Lindquist Bros., on Main Street when it opened in December 1919. Six years later, Henry partnered with Clair E. Wilson, an Iowa State alumnus, and the two men opened Wilson-Lindquist Cleaners and Tailors. Their operation was in two buildings: an office in the men's clothing store Jameson's, 2540 Lincoln Way (now Sizzlin' Cabana), and a cleaning plant in the Palmer Building, 112 Hayward Avenue (now empty but once was Boyd's Dairy and Battle's

Bar-B-Q). A couple years later, the business moved to the Cranford Building and the plant to near downtown. Business thrived, and in September 1930, Wilson-Lindquist Cleaners & Tailors celebrated the completion of its new $9,500 plant at 120 Hayward Avenue. Their partnership was dissolved four years later, but Lindquist returned in 1936 by buying the business from Wilson, who went into real estate. Lindquist continued in the cleaning and tailoring business until his retirement in 1946, and then his son, Norman, took the reins. The name changed in later years, but the building remained home to a cleaning and tailoring business until the early 1980s. It was torn down in 2016.

Salom Rizk was a Syrian-born immigrant who arrived in Ames in 1928. Barely grasping the English language, he immediately fell in love with the Iowa State campus but wasn't ready for college courses. At age twenty, he enrolled in the fourth grade. Rizk would go on to have great command of the English language—and its "mess of sounds"—and began to earn the reputation as a great public speaker. In 1930, he left his restaurant job and opened Collegiate Shoe Shop at 2524 Lincoln Way, a building constructed in 1917. During the Depression, he offered to fix students' shoes for free since many couldn't afford it, which earned him a good name in the Ames community. He took that business plan to the National Shoe Dealers convention in Chicago in 1932, and within a year, hundreds of Midwest shoe shops had adopted it. He left Ames in the late '30s to become a consultant and speaker, where he found success. The shoe shop went through more owners and names—Henry Castner, Russell Schwertley, Campus Shoe Service—but remained a shoe store through the mid-1980s.

College Savings Bank is a standout because its total assets were strong enough that it was one of the few permitted to operate during the bank holiday in 1933. In April 1935, it was the scene of a daylight robbery by three men, who came in with shotguns. The three people working at the bank and the customers were taken as hostages during their escape from Ames. The two bankers were released around Franklin Avenue. In the end, the robbers, who stole $5,000, had a falling out—one was killed by the other two; a second turned state's evidence, implicating the third; the third committed suicide.

Joe Whattoff, an English immigrant who arrived in Ames in 1911, opened the Whattoff Gas Station at the southwest corner of Hayward Avenue and Lincoln Way in 1928. Four years later, a new building was built for the business, which also did window washing, fluids check and interior sweeping. But it wasn't long before the effects of the Great Depression reached the

area. There were several people who couldn't always pay their bills upfront. Whattoff was a charitable person, so he let them pay on credit; he wasn't alone, as other Campustown business owners did the same. However, the College Savings Bank wouldn't let Whattoff pay his loans on credit. In 1936, the bank took possession of the gas station, land that became the bank's drive-up building several years later. Wasting no time, Whattoff secured some land down the street at 118 Hayward Avenue (torn down in 2016 for a mixed-use building) and built a second Whattoff Gas Station. It was only a few years into operation when World War II began and his three sons—Don, Verne and Murl—left to serve. During the war, the service business dried up, but Joe carried on with whatever work came through the door, including bicycle repairs. After the war, his sons inherited the company. In 1947, the Whattoff Motor Company became a Studebaker franchise, though business was slow when it started. Don and Verne had poured their savings into the company, but a couple years later, business boomed, often outperforming other Ames dealerships. The company is best known for the Trailer Toter, which created a retractable frame that allowed a truck to pull a long trailer and stay under some states' length laws. Needing more space, the Whattoff Motor Company moved out west of town in 1956. The California-based manufacturer Bourns took the space until the early 1970s. The building was then transformed into Campus Plaza.

In the spring of 1938—five years after the end of Prohibition—both students and residents packed into city hall to say they didn't want any more class B beer permits, which allowed for consumption on the premises (restaurants, cafés), to be granted in their neighborhood. A petition of one thousand signatures, all students, was presented to Ames City Council, and in June, an amendment created a specific beer zone in downtown Ames. Though Iowa State's grip on students' temptations had been in decline for several years, there was strong community support to rid the area of alcohol. "Beer parlors may be the breeding places for things much worse," said Quaife Ward, a student and petition signer, according to the *Ames Daily Tribune*. Andy Maitland, owner of Andy's Place (where Café Beaudelaire is today), strongly objected, believing the real problem was the drug and pharmacy stores, which had different permits (class C) for consumption off premises. Two others in Campustown also had on-premises beer permits: Francis' Sandwich Shop, 2604 Lincoln Way (torn down in the 1960s), and Iowa Cafe, 105 Welch Avenue (now a part of Copyworks), formerly called the Scoreboard and a popular student hangout in the 1930s. There's little written evidence that drinking was a problem within the student body at

this time. Yes, some students drank—the legal age was twenty-one—but the action in 1938 seems preventative. This was the first time beer was available in Campustown, too. Before Prohibition, it was state law that a tavern couldn't be located within two miles of Iowa State. Skirting around the new 1938 rules, the three restaurants applied for class C permits, and because the city didn't have the power to regulate that permit, they were approved. In 1941, West Ames became dry. Local drugstores and grocers stopped selling beer, and in the end, Andy's Place and Sovereign Grill, formerly Iowa Café, opted not to renew their permits.

Knapp Street: Campustown South

In September 1919, Samuel V. Whittaker and E.R. Sloane planned for a new business block at the corner of Welch Avenue and Knapp Street. It was a good location, just down the street from where the streetcar and interurban lines met and in the middle of a neighborhood dominated by fraternities and clubhouses. This was the second business project of Whittaker's, who had built a drugstore on West Street (see chapter 8) and attempted to build a movie theater. His original project for Knapp Street was ambitious, with a ballroom on the second floor. The store on the ground floor would also serve as a waiting station for the streetcar line. However, not all of the vision panned out. The Knapp Street Supply Store at 2419 Knapp Street opened in 1920 with Elber W. Renner, of Iowa State's dairy department and an alumnus, briefly operating the store. He soon left town for a new job, but his father, Oscar, took the helm. Selling toiletries, tobacco, candy, paper, photography supplies and select clothing items for men and women, the store carved a market for itself quickly. Its soda fountain also proved quite popular. Oscar was still operating the store when he died of a heart attack in 1939.

A few years after Knapp Street Supply Store opened, another store appeared. Beman's Groceries & Meats, at 2422 Knapp Street and operated by grocer Garfield Beman, had Iowa State–made butter that was a highlight of its food selection. It's possible Beman ran Knapp Street Supply briefly, and he and one of his sons—Estey, Ackley or Fred—were likely the ones behind the Beman & Son grocer on Lincoln Way a few years prior. There's no consistency in the newspaper spelling of Garfield's name, but Beman is correct. The family lived upstairs above the store. In May 1930, the business

Located at 2416 Knapp Street, this is the only remaining building from when the small stretch of Knapp had a few stores on it. *Author's collection.*

was sold to W.H. Brown, but Brown Grocery & Market became Beman's once again in 1934 when Garfield bought it back.

In 1932, barber Fred Beman, Garfield's son, opened a barber and dry cleaners nearby (2416 Knapp) but a few years later dropped the barbershop business. The cleaners remained until the mid-1940s, when Garfield moved his store to the location. He retired in 1949. The three businesses were as big as the commercial strip became. When Ames's first zoning ordinance went into effect in 1930, a small node from the interurban tracks and about 150 feet to the west was zoned for "local business." Of the two stores that remained into the 1950s—2416 and 2419 Knapp—both remained viable for several years.

In 1940, Earl Beaty bought the Knapp Street Store. He ran it for twelve years before going into the real estate and insurance business in 1952. It next became Jiffy Lunch. In the 1960s, the small restaurant went under a few different names—Broken Drum, Dort's Hut Cafe, The Inn—before Iowa State wrestling coach Harold Nichols opened a wrestling equipment and health foods store.

Bob Sucher purchased Beman's in February 1951, naming his store Bob's Superette. Not long after opening, the place was robbed at gunpoint. On

September 19 at about 8:40 p.m., clerk Tom Erwood, a college student at the time, emptied the cash register of more than $200 in cash and checks at gunpoint for two robbers. Bill Nelson, also a student, entered the store and was backed up against the wall by the two. When the robbers left, both Erwood and Nelson were forced to lie down at the back of the store. Erwood soon called the police. Paul Strennen took over the store in 1962, renaming it Paul's Superette, and was robbed at gunpoint on the evening of February 24, 1972, when Paul's daughter Paula, sixteen, was managing the store. The single robber took about $100. Paul's other daughter, Judy, twelve, was also in the store—but enough about robberies. Paul's closed up a few months later, and a new building—the current one—was later erected on the site. The Harold Nichols Wrestling Equipment store moved to the location in the early 1990s when the other building was torn down. Though it remains unused today—and zoned residential—it remains in the family.

In 2012, during a resurfacing project, the railroad lines at the intersection on Knapp Street were discovered under the pavement. It was a surprise because the tracks were thought to have been taken out in the 1960s.

CHAPTER 5

WORSHIP IN CAMPUSTOWN

The current churches in Campustown have become some of the institutions of the neighborhood. A small church was established around the turn of the century, but it only lasted for a decade. Like most college campuses of the time, there was a chapel for students' spiritual needs during Iowa State's early years. By the 1910s, there was a growing need for student ministry, and various churches from Ames and other neighboring communities had begun busing students every Sunday to their worship services. Churches sprang up from time to time for the next several years, most of which are still in Campustown today.

Many churches saw their most active times in the 1950s and 1960s from a boom in population at Iowa State, as well as West Ames in general. However, that could also be attributed to the Iowa State student body at the time, which was focused on agriculture and engineering and led to a conservative campus. This was compounded by McCarthyism and anti-communist sentiment across the country—going to church meant showing a bit of patriotism. Church life is a key memory for former residents and students. It meant dressing in your Sunday best and having lunch somewhere in the neighborhood after the service was over. The pastors' sermons and other lectures might also regularly be heard on the local radio.

Today, the easy accessibility to transportation has long cut the ties to having a congregation mostly dominated by those living in the neighborhood. Many current congregations only see a small number of attendees from the local area. The large percentage of student involvement in church activities

peaked a few decades ago, but every church still has an active student ministry for college students. With a growing student population in the past decade, some are seeing a palpable increase.

To some people, the students have changed a lot over time, while others think that, at their core, students are much the same, even with a society that's more centered on one's self and technology. All the churches, which have varying degrees of a student outreach program, take pride in being next to Iowa State University. The students add a bit to the ministry and worship that you can't find anywhere else. Having the lifelong Ames resident in the same congregation as the freshman who will be gone in four years creates a special environment, and each party, including the ministers, takes something special away.

The places surveyed here aren't the only religious centers of Campustown. You can find a history of Collegiate Presbyterian Church in the chapter on West Gate. Several other religious groups have come and gone or are still present in Campustown today. The Church of Jesus Christ of Latter-day Saints has a space at the corner of Chamberlain Street and Lynn Avenue, and the Mennonite Fellowship had a presence in Campustown in the 1980s and 1990s. Some churches opened their spaces to other local religious groups, too. Campus Plaza, 118 Hayward Avenue, was occasionally home to small student ministries and campus student groups that needed a place with low rent that was close to campus. Faith was immensely important to Don Whattoff, the building's owner for many years, and he'd always try to make sure those groups had a space.

Ames Meeting of Friends

Around the turn of the century, Ames Meeting of Friends formed and began meeting every Sunday at the Fox Schoolhouse (see chapter 3), led by local farmer Isaac Ellis. Composed of members from the town of Ontario and West Ames, it was affiliated with the Bangor Quarterly Meeting, the Friends congregation in Marshalltown. In 1900, collections were taken in Ames to give to the Friends Church so it could have its own building.

The Cole family arrived in Ames in 1899. Jacob brought his daughter, Agnes, an alumnae of Iowa State, and his son, Harry, with him, and each purchased land. In February, Agnes bought two lots at the northwest corner of Pike (Sheldon Avenue) and Boone (Lincoln Way) Streets for

$250. In 1902, she donated land for the Ames Meeting House but also ensured the house would revert back to her if the church closed. Ellis was named the first pastor when it opened the following year—the first church in West Ames. Ellis, who served without compensation, was in Central City, Nebraska, in 1904 but returned to the Ames Meeting House in 1905. In 1908, Fred Coppock became the minister for a year before returning to his former duties in Ankeny. In 1909, Sanford Pickering became the last pastor of the Ames Monthly Meeting. Because the congregation takes an active part in worship and church business, a pastor isn't a necessity for a Friends congregation.

In 1912, with a congregation of forty-eight people, Clerk Leah T. Scoltock—holding a position that is like a manager—delivered the news that the Ames Monthly Meeting was being discontinued and the house was to be closed, with the hymnbooks, benches and equipment given to the Salvation Army. A Friends church in Ames wasn't organized again until 1923. The house went back to Agnes Cole, who then tried to get downtown churches to buy the property, but none would consider her offer. She turned down an offer to convert the house into a movie theater (see chapter 4). Instead, she decided to begin a laundry service. However, facing plenty of competition from other options available in the area, it was a financial failure and was abandoned after two years. In 1916, suffering from deterioration, the main sections of the house's structure were taken apart to make room for the apartment building that currently stands there, called the Suites on Lincoln Way. The church's foundation was used for a small apartment house, the Lincoln Annex, at the rear of the property. It was demolished a few years ago.

FRISBIE HOUSE

First Congregational Church, now the Ames United Church of Christ, is the oldest existing church in Ames. The church was founded in 1865, and the building, which it still uses, was completed in September 1866. Even as more churches were built in Ames through the years, First Congregational had strong ties to the college community, with several members and students attending—some of whom were Sunday school teachers. In 1906, the church hired an associate pastor who did outreach to the college community and, most specifically, the students.

Frisbie House Student Center was built in 1916 and named for a Des Moines Plymouth Congregational Church minister, Reverend A.L. Frisbie. Located on Lincoln Way next to St. John's by the Campus and across the street from Lake LaVerne, the student center was built to be a "home for Congregational students who were away from their home churches." Religious study classes were held at the house so students didn't have to go to the church downtown, and they were well attended, averaging about one hundred students at the peak. Trying to grow the student ministry, a few parties were held in the mid-1920s. When the church's parsonage began to be used for Sunday school classes and soon became home to other church staff, Reverend Henry Hawley and his wife, Theodosia, moved to Frisbie House in 1926. The house—managed by the student committee of the downtown church but also funded by the state conference, centered in Des Moines—fell on hard times during the Great Depression as the church struggled financially and the student minister position was eliminated. Student attendance was down, but local members, including some students, were dedicated to keeping it going. It was remodeled before World War II began and was fully back to life after the war.

As culture changed, the church took on a personality of its own. By the late 1960s, the house, now operated by the United Campus Christian Ministry (a joint ministry project between five area churches, including Collegiate Presbyterian and First Baptist), was known for its outdoor concerts in nice weather and its visitors, most of whom had long hair and wore sandals (hint, hint). One of the most controversial activities at the house was draft counseling. Many organizations had meetings there, including the local Quakers and Young Democrats. It held some Bible classes but would also hold classes to discuss films such as *Goodbye, Columbus* and *Midnight Cowboy*. It was becoming a concern because the people using the church were taking a firm stance on the issues of the day and connecting with students, which didn't always go over well with those who funded it. In its final years, it was strictly a meetinghouse. It was purchased by First National Bank in 1976 and later torn down for its offices. Those offices were torn down in 2014.

St. John's Episcopal Church by the Campus

St. John's Episcopal Church by the Campus traces its roots back to 1876. Organized as Trinity Mission, the church changed its name to St. John's

in 1893. The church's first home, finished in 1899, was at Fifth and Clark Streets, though the building did move once when the city needed to make room for a new school. In 1919, the church bought land, which included a house, in Campustown at the southeast corner of Lincoln Way and Stanton Avenue. The house served as a rectory (the Episcopal version of a parsonage) and student center for the next decade. In September 1929, the old house, built in the early 1900s, closed to make way for the new church. The completed building was dedicated on May 4, 1930. The Great Depression soon put pains on the church to pay off the mortgage, but the story goes that even the children of the parish were contributing their pennies to prevent a foreclosure. It worked. A house to the south at 116 Stanton Avenue, built in 1911, was purchased in the early 1960s and called the Canterbury House. It became the new student center and was torn down in the mid-1990s; the church parking lot is now on the site.

For the first several years, worship service was conducted by neighboring ministers. The church didn't have a rector of its own until 1919, when Father LeRoy Burroughs arrived. He remained at the church for forty-two years. There have only been two others since him: Paul Goodland, who served from 1961 to 1991, and Al Aiton, who has served since 1991.

For more than thirty years (1964–96), the Episcopal Parish of Ames comprised two churches: St. David's and St. John's. The congregation of St. David's, which began in 1964, first met at Stevens Funeral Home and then at Northminster Presbyterian Church. In 1974, St. David's completed its church building, which is at the current site of Windsor Oaks on Adams Street. The two congregations rejoined in 1996. Located under the skylight and at the fireplace hearth, the Gathering Area is dedicated to the St. David's congregation. In 1995, St. John's undertook an extensive (and much-needed) renovation of the building and helped create some necessary space.

Collegiate United Methodist Church and Wesley Foundation

The story goes that Don Handy, a student in the late 1900s, told his father, Reverend Elias Handy of Grinnell, that the greatest need for students was a church near campus. At the time, the only church besides the services at Iowa State was the small Friends Church. Reverend Handy gave a sermon on campus in November 1908, perhaps checking out the situation

himself. In January 1910, a commission was formed by the Iowa Annual Conferences of the United Methodist Church to find pastors for student ministry at the state schools. In January 1913, Reverend William Hints began ministry to students in Ames but was headquartered at First United Methodist Church, located downtown. After Hints, Reverend William Handy, Elias's son and Don's elder brother, became the student pastor. Like other local families and Reverend Hints, Reverend Handy stressed the need for a Methodist church in West Ames and was keen on a program that would include local families, not just students. With roughly seventy-seven Methodist families in the area, the congregation organized as the Campus Methodist Church on September 24, 1916, and Sunday services were held in Champlin's Hall at the corner of Welch Avenue and Lincoln Way. The congregation grabbed the location as soon as the Presbyterian congregation vacated it for its new church. The Wesley Foundation of Iowa was incorporated in 1917, providing financial support to the campus ministry in Ames. In 1914, property for a church was sought out, and in August 1919, after it had been held in trust, land and houses were acquired on Lincoln Way and some adjacent land was purchased, too. One of the

The original piece of the Collegiate United Methodist Church and Wesley Foundation, the sanctuary on the east (left), was completed in 1926. *Courtesy of Collegiate United Methodist Church and Wesley Foundation.*

houses was moved to 410 Welch Avenue to became a church-sponsored student co-op, and another became the church parsonage.

Wesley Hall, more commonly called "The Shack," was completed in January 1921 and used extensively by the church and student center, earning a special place in the hearts of early members despite never being an attractive structure or long-term possibility. It also proved incredibly popular among campus organizations, which frequently requested its use. By 1924, the church, now Collegiate United Methodist, and Wesley Center had outgrown The Shack. Plans for a sanctuary that could seat 1,200 were drawn in 1925, and the building (the east side of the current complex) was dedicated on June 6, 1926. The Shack was torn down in 1936. A basement was constructed for the student ministry in 1919, but the structure itself didn't move forward again for years. With a congregation of more than 1,500 people and the debt on the 1926 sanctuary retired, fundraising began to finish the Wesley Foundation Student Center in June 1953. It was dedicated on November 18, 1956. In 1951, the church purchased the house to its west, which had been a boardinghouse for decades, from Cora McCarty. McCarty built it in 1915 when the church bought her neighboring property. Remodeled, the house was named the Epworth Annex and featured a basement called the Rumpus Center for high school youth. It later served as a parsonage and then a home for college students for years. In the 2000s, it was also home to the Prairie Flower Children's Center. The house has also been a reduced-rent home for students who, in return, do various tasks for the church a few hours per week. In the 1960s, the church purchased some adjacent property at 113 Hayward Avenue, and the house, the Asbury House, became a parsonage. In its later years, it was a home for students and the custodian and then a women's center. It was demolished in 1985.

By the mid-1990s, the church was again faced with inadequate space. Wheels were turning on an expansion when the Campus Baptist Church building and property became an option; that church (now CrossRoad Baptist Church) was going to move east of town. In 1999, the two churches agreed on a $1.5 million price for the property. The main building is now known as the Annex, and the building to its north (112 South Sheldon, the original Hy-Vee building) is called the Lighthouse and leased to CrossRoad for its student ministry. The Annex is mostly populated with local nonprofits such as Creative Artists Studio of Ames (CASA), Friendship Ark, the Arc of Story County and the Iowa Able Foundation. It also has worship and meeting space used by the church, nonprofits and other local and student groups. Another expansion to the church began in 2007 to add some needed

space. The addition altered the look of the church along Lincoln Way and, while it still exists, enclosed the courtyard.

Several thousand students have come and gone at Collegiate United Methodist Church through the years. The church balances both a large student ministry and a traditional congregation. It's a rare setting since the Wesley Foundation is one of only two in the country that shares a building staff with a local congregation. In 1950, the church was said to have been the church home for one-fourth of the students and faculty of Iowa State. Small group fellowships, which are still important to the ministry, go back to the church's early days. In more recent years, the church has explored different types of Sunday worship services. The early Sunday morning service is a little more modern ("blended"), with a band, but keeps some of the traditional liturgical service. The second service is much more traditional, with an organ and choir. For a few years, there was Faith Spring, an alternative Sunday evening service with a more open atmosphere held in the Annex. It started in the early 2000s but has since morphed into a more mobile and campus-centered service. The church remains active in offering several ministry opportunities, such as mission trips, community service projects, a midweek chapel at the Memorial Union and study groups for young adults.

Memorial Lutheran Church and Student Center

In September 1920, the Trinity Lutheran Church in Boone chartered a bus to take students from the Iowa State campus to the church for Sunday worship. It was quite a commitment in the early days since the roads at the time were far from reliable, and there is at least one account of the bus getting stuck on the way. The Trinity pastor came to Ames twice a month for Sunday evening fellowship with students. By the late 1930s, a church near Iowa State had become a necessity for student ministry. The regional group National Lutheran Education Association, Iowa District West of the Lutheran Church–Missouri Synod, and soon-to-be congregation members—keep in mind, there was no church or organized congregation yet—raised money for the land, building and furnishings. For $3,700, the church bought land at Lincoln Way and Lynn Avenue next to the Atkinson Lodge. On November 17, 1940, Memorial Lutheran Church was dedicated, and Reverend Edgar J. Otto became the church's first

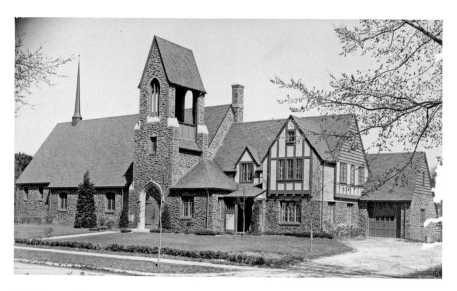

The Memorial Lutheran Church and Student Center not long after its 1957 addition was complete. *Courtesy of Memorial Lutheran Church.*

pastor. In 1945, the church bought the Atkinson Lodge and property to its northeast. The Atkinson Lodge, a boardinghouse, became the Concordia Club, a fraternity for Lutheran students, and then the local chapter of Beta Sigma Psi when it was installed in 1949. The fraternity moved to Hyland Avenue in 1956, and with a congregation of five hundred people, the lodge was demolished to make way for Memorial Lutheran's 1957 building. The new addition greatly increased the size of the worship space and added a new altar window. By 1951, the church had purchased more land to the east, which is now its parking lot. Another addition was done in 1990 to add offices and classroom space. Wanting a church devoted to the congregation's spiritual growth and without the student ministry, some left to found St. Paul Lutheran Church in 1951.

Little is recorded of any resident members' early involvement, and the first building committee had no Ames members. However, throughout most of the church's history, the resident members have aided the church's growth and maintenance. As a town and gown church, Memorial Lutheran has always had one arm in student ministry. Founded shortly before the United States entered World War II, the church was contributed in activities for the war effort and was an army and navy recreation center in the summer of 1943. A staple of the church's past was its Sunday night dinners for students, which were always popular

at just a few dollars and were provided by the women's ministry. There was also Friday entertainment and, until more recent years, study space for students. While student attendance has declined since its peak in the 1950s and 1960s, the church still has 200 to 250 students every Sunday and has an established ministry of English and Bible classes and social gatherings for international students and their families.

First Baptist Church

Though First Baptist Church's predecessor, Squaw Creek Church, was established in the 1850s and met at Hoggatt School, it had disappeared by the time Ames appeared. On July 11, 1868, First Baptist Church was established with eight charter members and made its home near downtown Ames. In March 1930, the church, wanting to take grander steps toward student ministry, built the Roger Williams House on Lynn Avenue, and Reverend R.B. Davidson moved in as the student minister. Davidson died suddenly in 1936, but the student ministry grew, reaching 110 students in 1942. The Roger Williams House, named for the seventeenth-century theologian, was sold in 1949 and torn down for the current Kappa Kappa Gamma house. Devoted to building a church, student center and parsonage, the church bought land at 200 Lynn, and with money from the Board of Education of the American Baptist Convention and the Iowa Baptist Convention and a few members who mortgaged their homes, First Baptist built its current house of worship. It was dedicated on May 14, 1950. In 1960, more land was purchased and the Covenant House was created. Located south of the church, the house was a home for eight students who were members of the Covenant Program, a resident program of study, worship and action; others were involved but didn't live there.

First Baptist Church, which is affiliated with American Baptist Churches USA, is on the liberal end of the Baptist Church spectrum. It's a progressive church and has some activism in its congregation's history, especially during the civil rights movement and the Vietnam War protests. The church currently shares its building with the Center for Creative Justice, a nonprofit founded in 1974 that provides adult probation services for all levels of crime. The center's home in the 1980s and into the 1990s was the former Covenant House. The house was sold a few years later and replaced by the current apartment building in 2001.

When Reverend David Russell, the church's current pastor, first arrived at the church in 1999, there was a bit of uncertainty about its fate, but even with a small congregation, the church enjoys the connection it has to the Campustown community. In the last decade, several apartment buildings have replaced the old houses once surrounding the church, making First Baptist's steeple, once seen throughout the area, a bit harder to spot. Today, about seventy-five people attend Sunday services.

CAMPUS BAPTIST CHURCH

Campus Baptist Church began in 1934 when four men met and agreed that Ames needed a new church with a fundamental teaching foundation. The group, called the Gospel Mission, originally met downtown in the building now home to Great Plains Sauce and Dough Co. It soon moved to campus at the Memorial Union and then Alumni Hall (now Enrollment Services Center). In 1935, the small group met at the home of Vernon Marsh, 210 Ash Avenue (now Greek houses), and began formally establishing the church. The following year, the church, Ames Bible Church, moved to a place at the corner of Lincoln Way and Howard Avenue that was constructed for $3,500. It included a homemade pulpit and folding chairs for seating. The name Campus Baptist Church was established in 1938. The church's longtime site, 130 South Sheldon Avenue, was purchased in 1947, and the church began worship at the new location the following year. A Sunday school wing was added to the south of the building in 1955. An addition, which included an auditorium, was completed in April 1963.

In 1953, Campus Baptist Church bought some neighboring land for more parking, which was becoming a problem. The congregation could then use the Hy-Vee parking lot to the north on Sundays, and that would sustain the church for a few years. In 1976, it purchased the land north to the corner of South Sheldon Avenue and Lincoln Way, including the Hy-Vee building and space developed by church member Joe Whattoff. The former home of local favorites Dairy King and Cyclone Inn, the corner business became Felix and Oscar's, a pizza place specializing in Chicago-style pizza that was based in Des Moines. Its first location near Drake University had opened only a year prior. However, since the restaurant was leasing from Campus Baptist Church, alcohol would not be allowed. The business closed after about five years. In the basement of the property was Wutzundar, a small venue mostly

known for its music—and a hangout for the student activist crowd. The church sold the land a few years later, and the corner building was torn down for a Taco Bell, which closed in 2010. Dunkin Donuts opened in the location in 2013.

By the late 1960s, attendance during the school year ranged between four and five hundred people. Affiliated with the General Association of Regular Baptist Churches (GARBC), Campus Baptist Church was strict in its rules for membership. No one could be a member of a secret fraternal society, and alcohol was not allowed. Compared to First Baptist on the other side of Campustown, Campus Baptist was on the other end of the Baptist spectrum. Pastor Paul Tassell renounced the Vietnam Moratorium in November 1969.

A longtime supporter of overseas ministries, Campus Baptist Church began sponsoring missionaries in Africa in 1942. A bus ministry began in the 1960s and became one of the staples of the church. At its peak, a fleet of half a dozen buses would go around to all parts of town, pick up students and bring them to the church on Sundays. Routes even went to the Pammel Court residences on the north side of the Iowa State campus, where it would pick up college students. Church member Verne Whattoff was perhaps best known in the community as the guy who drove the bus around and picked up anyone who looked like they needed a ride. He'd take the opportunity to share his faith with them, which was incredibly important to him.

By the late 1990s, Campus Baptist Church was becoming too cramped in its location. Parking was a serious problem, and the church building itself was becoming rather packed. In 1999, the church sold its properties to Collegiate United Methodist Church and moved out east to where Highway 30 meets Interstate 35. The church still rents the former Hy-Vee building, called the Lighthouse, for its student ministry at Iowa State.

St. Thomas Aquinas Church and Catholic Student Center

With the growing population from the naval training programs at Iowa State in the 1940s, St. Cecilia Church could no longer hold all the student parishioners. Fathers John Brickley and Joseph Kleiner secured the use of Great Hall in the Memorial Union for Sunday Mass and established an office for student services. In 1945, the Porter Lodge, "The Old House," between Ash and Lynn Avenues on Lincoln Way was purchased for $13,800

from Ben Porter. The large house was originally the East Parker clubhouse, which dated back to the turn of the century. Some walls were removed, and it became a chapel for daily Mass and student outreach. On April 8, 1947, St. Thomas Aquinas Church and Student Center was incorporated, with Father John Supple appointed its first pastor. About 75 families and 1,154 students were the first parishioners. Ground was broken for the student center and chapel in the fall of 1948, and construction was completed the following year. The Old House was torn down in 1953 as the second building phase was underway. A new basement was added and, with seating for 400, became the new chapel. By the early 1960s, the number of families had more than doubled and student attendance was more than 1,300, so the erection of a sanctuary able to seat 900 began in 1962. It was dedicated in February 1964. By 1972, the number of families had grown to 250, and 3,000 ISU students identified as Catholic.

Like many Campustown places, parking has always been an issue. For its large congregation, the church only had 42 parking spots on site. The rest of the congregants would park on the street or at the Memorial Union Parking Ramp across Lincoln Way. With an anonymous donor providing a $3.2 million donation, a two-level parking deck was soon underway. In

The original structure of St. Thomas Aquinas Church and Student Center was finished in 1949. In the background you can see the Delta Upsilon fraternity house. *Courtesy St. Thomas Aquinas Church.*

October 2011, the nine-apartment Cardinal House at 129 Ash Avenue, which the church purchased in the mid-'70s and had been home to many church staff in its time, was demolished. As a boardinghouse built in the late 1900s, approval from the city council was required for the demolition of Cardinal House because it was home to a fraternity in its past. The parking lot, which contains 171 spots, was in use in late 2012.

St. Thomas Aquinas, named for the thirteenth-century Italian theologian and scholar, has always been a popular spot for students. From its beginnings to today, many students have gone to the student lounge to work, study and hang out with friends. In its early days, morning Mass at 6:30 and 7:05 a.m. was often followed by breakfast at the Memorial Union, and an hour of coffee and socializing at 4:00 p.m. was a student favorite. Like most churches, Sunday night dinners were staples of yesteryear, and Friday night sock hops were quite popular, too. Father Supple and his ability to remember everyone was beloved by the parishioners. The Newman Club, which focused on student involvement, brought several students together and created a student atmosphere of being among their own (Catholics). Newman also had its own social events, such as ballgames, costume parties and dances. In the mid-1950s, nearly nine hundred students were part of the Newman Club.

Though more moderate in its worship service today, St. Thomas Aquinas had a congregation that was preparing for future changes. In 1970, guitarists and organists could both be part of the worship service—the first use of guitars in the Archdiocese of Dubuque, of which the church is part—and Wednesday included an experimental Mass for young people. It was a result of Vatican II in the mid-'60s, which marked a shift in church teachings and the sociopolitical shift that Iowa State and the country had been going through. It allowed Mass to be done in English, among other things. Perhaps female priests were even around the corner. The ideas show the congregation's thinking in the 1970s. There have been difficulties in the balance between church and students, but the two also improve the church community as a whole by adding something special to the spiritual experience. Today, about 1,700 people attend the church's services.

CHAPTER 6
THE GREEK LETTERS

Few campuses had easy relationships with fraternities in the nineteenth century, and Iowa State was no exception. Their secrecy was long protested by the students, who figured members could only be up to evil things behind closed doors. The first fraternity (Delta Tau Delta) was installed at Iowa State in 1875, not long after the school opened. A sorority (Pi Beta Phi) followed a couple years later. When President Adonijah Welch let Delta Tau Delta use classrooms for meetings, the triggers were sparked. Tension between fraternities and antis (those who were against fraternities) were present even in the earliest of days. When the *Aurora*, an early student publication, finally began to acknowledge fraternities—it didn't for many years—it didn't put them in a positive light. One of the founders of the *Iowa State Daily* was an adamant anti, and it showed in several early pieces. In 1886, William Chamberlain became president of the university, inheriting a growing problem in the student body. His liberal fraternity policy cost him student support, which eventually played out publicly. The next president, William Beardshear, quickly put a ban on new pledges at the fraternity and two sororities (Pi Beta Phi and Delta Delta Delta). Despite the change, Delta Tau Delta defied the rules and initiated a couple students secretly, as did Pi Beta Phi. The Delts also questioned the legality of Beardshear's rule, but the courts sided with the school policy. Despite some appeals, the Delts surrendered. Some suggest the fraternities and sororities went underground and out of view to the student body and college administration. There's little evidence to support the claim, but much of that era is lost history.

Return of Greeks and Early Housing

In the late 1890s, the campus dining hall was known for not having good food, and students weren't quiet about their dissatisfaction with it. In May 1897, a group of twelve men revolted against "the nauseating and villainous cookery in the old Margaret Hall dining room of the college" to form the club Noit Avrats, which, spelled backward, is "starvation." In its early days, the club was limited to twelve men, which was also the number of people who could sit at a table in the dining room. Its semi-annual banquets were some of the most talked about social events of a school term. Despite being a club that was fairly secretive, it was tolerated by Beardshear, who was an embodiment of the college's in loco parentis policy. In time, more clubs like Noit Avrats popped up. The S.S. Society (composed of women living in Margaret Hall) and Tri-Serps (composed of men and with an insignia of a trident encircled by a serpent) organized in 1900. Part of Old Main, the building that was the home for several students and general campus life, burned that year, but when the remaining structure burned in 1902, a housing shortage began. President Beardshear died that same year. Albert B. Storms became the next president, and only days after he began, he had a meeting with a new local student group, the Dragon Society, about allowing local fraternities to organize. In early 1904, with a housing shortage and support from Iowa State's board of trustees, Storms restored the Greek letters on campus. An early student government was also established, an explicit alteration from Beardshear's policies. There was student freedom, but it was regulated. By 1910, thirty Greek houses had been established.

Within months of Storms lifting the ban, a fraternity was installed on campus. Sigma Nu was established in April. Delta Tau Delta alumni organized the Hawkeye Club during the term, and the women's club Iota Theta was formed. In 1905, the Dragon Society was installed as Sigma Alpha Epsilon, and Tri-Serps was installed as Beta Theta Pi. The Colonnades organized in 1905, too. Over the next several years, local clubs abounded and included Ozark Fraternity (1906, created by those living at a house on Hyland Avenue because they thought other fraternities weren't social enough with non-fraternity members), Omega Delta (1907, a sorority intent on becoming Delta Delta Delta), Arcade Club (1907, a boarding club of twenty-four men who lived in the same house to economize the cost of living), Antler Club (1907), E.S. Club (1907, founded by six engineers and later called Epsilon Sigma), Adelante (1907, to break up the political clique controlling campus positions), Colonials (1908, a fraction of Colonnades),

Craftsman Club (1908, organized for Masonic students), Zeta Sigma Zeta (1908, a splinter from the Antler Club), Gamma Theta (1909), Alamo Club (1909), Rho Sigma Gamma (1909, often called the Red Shirt Gang), Palisades Club (1910, a break off the Colonnades), KKK House (1910, later named Kappa Kappa Kappa) and Inomene Feliae (1910, a local sorority). That's not all of them. More organized (and vanished) in the following two decades. These are social clubs, many of which would go on to be national Greek chapters. This list doesn't include the general student clubs that formed in the early twentieth century.

Fraternities were the dominant force in these early years because there were no on-campus living quarters for men. The women had a few dormitories on the east side of campus, but the men wouldn't have anything until Hughes Hall was completed in 1923. Many of these clubs had houses at various locations in Ames, including near downtown, but early on, few clubhouses had the funds to build their own. They were rented from various landlords, and these houses weren't small. At two or more stories in height, they dominated the landscape surrounding campus and contained a dozen or more rooms and often included large decks and columns. Young fraternities needed members to fill these houses. A lack of members often spelled doom for a fraternity.

These houses at West Street and Campus Avenue show how large the early boarding and fraternity houses were near campus. These two were demolished in 2016. *Courtesy of Hank Zaletel.*

As discussed in chapter 2, clubs and Greek houses first appeared in the West Gate area. Even before the possibility of fraternities and sororities at Iowa State again, Noit Avrats built a clubhouse in 1903 right across from campus at the West Gate entrance. Sigma Alpha Epsilon built a house at 2717 West Street, between Sheldon and Hyland Avenues, in 1905. It still stands today. The Arcade Club started at 238 Hyland Avenue—like most West Gate neighborhood houses, it's been replaced by an apartment building—but moved the following year to the Noit Avrats house when that fraternity moved to Hyland Avenue (now Collegiate Presbyterian's parking lot). Adelante Fraternity, which is the longest-running local fraternity in existence, lived at the former Arcade residence during the 1908–09 school year. The Alamo Club, which became Lambda Chi Alpha in 1917, called the location home for the following two school years. Again, the Arcade Club moved after a year. Gamma Theta, which became Pi Kappa Alpha in 1913, lived there from 1909 to 1911.

The new Ozark Fraternity, which became Phi Kappa Psi in 1913, was the first inhabitant of 221 Sheldon Avenue. The house was next the home to Epsilon Sigma, which became Theta Xi in 1909. The Craftsman Club became a chapter of Acacia in 1909 and in the fall moved to West Street, where it remained for a few years. In 1907, Pi Beta Phi, formerly the local sorority Iota Theta, occupied a new house on Hyland Avenue. Theta Xi built a house on the same street in 1915. When a clubhouse was designed for a fraternity or sorority, it often kept serving as one. The Campustown vicinity was popular early on for Greeks, too, but since it was so spread out, the houses were scattered. West Gate, on the other hand, was more densely populated with them. Sheldon and Hyland Avenues became so popular for their Greek residences that a few writings called it "Fraternity Row."

Migration to the South

Even in the late 1910s, some Greeks still considered West Gate the preferred location for a house. Most of the lots on North Lincoln Way (Sheldon Avenue) and Hyland Avenue had buildings by this time, so the growth of West Gate was now to the west of Campus Avenue. Wanting to be close to campus, Greeks seeking to build didn't find the west side neighborhoods all that appealing anymore. Sigma Alpha Epsilon, which still occupied its house on West Street, was seeking a new location in 1921. The house was

worn down and had been used as barracks during World War I. Members were prepared to move north to the corner of Oakland Avenue and Forest Glen—an area without a Greek presence—but the owner refused to sell. Instead, land was purchased at 140 Lynn Avenue, and a large two-and-a-half-story house with brick and stone walls was constructed in 1928. Sigma Alpha Epsilon wasn't the first to migrate, but its story is a prime example of the Greek community's slow exit from West Gate.

The early rush to the Campustown area was centered on Welch Avenue. A preferred corridor almost immediately, the straight and easy access to campus sparked several early Greeks and clubs to settle on it. Hawkeye Club lived on Welch (where Battlecry Smokehouse is) for the latter half of the 1900s. State Club lived down the street (206 Welch) for a decade. Beta Theta Pi's residence at 121 Welch, at the northwest corner of Welch and Chamberlain Street, was still called Beta House when it was torn down in 1977—the fraternity had moved out fifty-five years earlier. Pi Beta Phi, Omega Delta (later Delta Delta Delta) and Iowa Club also had nearby residences in the 1900s. The appeal of Welch Avenue hasn't vanished; there are still a handful of Greek homes on the street. The earliest surviving fraternity house in the area is the former Phi

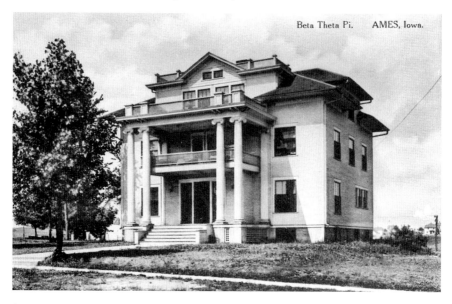

Beta Theta Pi. AMES, Iowa.

Seen here in around 1915, the Beta Theta Pi fraternity house, 121 Welch Avenue, was located at the corner of Welch Avenue and Chamberlain Street. *Farwell T. Brown Photographic Archive.*

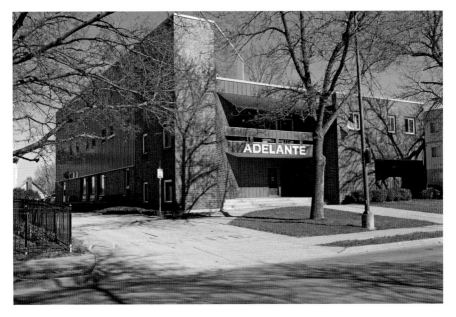

Adelante is the longest-running local fraternity in the country. The current house was built in 1972 and was the scene of a death during VEISHEA 1997. *Author's collection.*

Delta Theta house at the corner of Welch and Knapp, which was built in 1915. To the north, the Theta Xi house was built in 1931. Adelante built the house at 304 Welch in 1923 and then built the house next door, its current one, in 1972. A few buildings south of Knapp Street are former Greek houses, too.

Members of the Colonnades organized in a clubhouse at the corner of Lincoln Way and Lynn Avenue that was owned by Campustown business magnate Albert Louis Champlin and had once housed Hawley D. Miller's general store. This was also the club that had a serious typhoid fever outbreak in 1906 (see chapter 3). The Colonnades would splinter a few times, but one faction—the one that retained the original name—became Delta Upsilon in 1910. (Theta Delta Chi, Alpha Sigma Phi and Delta Sigma Phi can all trace roots back to the Colonnades.) Adelante began in the West Parker clubhouse, where the house for Sigma Alpha Epsilon sits. (The Sigma Alpha Epsilon chapter was suspended in 2015 for unspecified reasons. A member was investigated for sexual assault a few months prior.) Kappa Kappa Gamma bought its current lot when the First Baptist Church sold the Roger Williams House. Phi Kappa Psi built its grand house in 1922. The Kappa Alpha Theta house was a boardinghouse for students when built in 1916.

The Theta Delta Chi house was completed in 1910, making it one of the oldest houses in Campustown. The Colonials, predecessors to Theta Delta Chi, built it. *Author's collection.*

The Phi Gamma Delta house was built in 1917. The fraternity traces its roots back to Noit Avrats, the first student club to form after the ban on Greek houses in 1891. *Author's collection.*

Gamma Theta, a local fraternity, was the first to move to the Lincoln Way neighborhood (the north side of the Greek Letters neighborhood) when it took over Louis H. Pammel's house (where Pi Kappa Alpha's residence is today) in 1911. By 1914, lots were being advertised specifically targeting fraternities and sororities, and building was taking place throughout the area. It formed a concentrated point of the Greek community, which it didn't have before. Many of the Greek houses we see today were built in the 1920s and '30s, but a few are older. One of the oldest buildings in Campustown is the Theta Delta Chi house on Ash Avenue, which was completed in 1910 and constructed by the chapter when it was a local fraternity. That stretch of Ash Avenue—from Lincoln Way to Knapp Street—is now called Fraternity Row and consists of houses that were built for the Greek community. Phi Gamma Delta, the descendant of Noit Avrats, is located at the south end of the row.

However, Alpha Kappa Lambda still sits at the west end of Campustown on Knapp Street. The last active Greek house in the West Gate neighborhood was Triangle Fraternity, which was at 125 Hyland Avenue when it was suspended in 2003 for "multiple reasons," according to *Iowa State Daily* articles, including graffiti-ing campus with derogatory terms. The house was torn down in 2013 for a new apartment building.

Greek Life

For several local Greek houses, applying for a charter from a national Greek letter organization was a challenge. Many Greek organizations were centered in the eastern United States and mostly associated with liberal arts colleges. That didn't describe Iowa State, which was a land-grant institution, and many organizations were hesitant to expand to schools like Iowa State. These "cow colleges" and their inferior culture might ruin the Greeks' high standards. Delta Upsilon and Gamma Phi Beta needed some pushing and convincing for the local group to earn charters.

Some local Greek houses vanished during World War I when enrollment dropped. In the 1920s, there were a few mergers between various Greek houses. Alpha Sigma Phi, Phi Sigma Kappa, Chi Phi and others struggled during the Great Depression. Many went inactive before and during World War II, and only a few attempted activating again. Most fraternities became women's housing during World War II

since the women's dormitories were being used by the army and navy trainees on campus.

To students, Greek houses had an appeal because they were central to social life on campus for several decades. They were the groups organizing parties and other big events that people would be talking about the next week. Without the Greek community, there weren't many social functions for students living near campus during the Roaring Twenties. Lectures and concerts only did so much. Formals and fraternity dances might be in Campustown or on campus or elsewhere in the local area, and they always included an area man and his orchestra. Smokers became incredibly popular for the fraternities that could afford them, and some houses teamed up for them, too. In 1929, it was recorded that five-sixths of all social activities were conducted by the Greeks. However, only one-sixth of the men on campus were Greek. It was also found that two-thirds of the women living in the dormitories didn't date, and various industry officials were complaining about the awkwardness—for a modern term—of some of the men hired from the school. In response, President Raymond Hughes created a residence hall system that would become the on-campus counterpart to the social activities of the Greek houses.

There were troubles with the Greek community. As noted in Walter James Miller's 1949 book *Fraternities and Sororities at Iowa State*, which contains a wealth of information, some of it noted in this chapter, in 1910, a few years after the secretive and difficult Quo Vadis fraternity was installed on campus, a pledge was killed on the railroad tracks between Ames and Boone during initiation. The fraternity was promptly booted from Iowa State. Hell Week in the 1920s stirred a feeling of a fast and rough lifestyle in the campus fraternities. Already, fraternities had garnered a reputation as drinking societies, but the (surviving) evidence supporting that is minimal at best. Then there was the Beta Pig Affair. The Beta House loved to have pigs for a roast, but the house didn't always have the funds to buy a pig. One year, pledges were sent out to steal a pig for the roast, and when they found one, they ended up killing it because (surprise!) the pig didn't want to go with them. The squeals and trail of blood led police right to the Betas' basement. The pig belonged to Charles Curtiss, dean of agriculture at Iowa State. The house was suspended for a year, and some involved were expelled. During Prohibition, there was a federal raid at Sigma Chi for operating a distillery. Little was found, but some members were expelled. Some of the chapters' maids were known to earn extra income by privately entertaining members of the fraternity

in their rooms. It was something that the fraternities were able to keep from college administrators.

The local chapter of Theta Nu Epsilon—a secret fraternity that wanted its members, who usually belonged to another fraternity as well, to become candidates for campus political positions—was broken up in 1923. The fraternity was known as a heavy drinking and free love group and, like on many campuses, was banned at Iowa State. Theta Nu Epsilon, which had been overhauled in the intervening years, briefly returned to Iowa State in 1930.

In later years, participation in intramurals as well as members earning positions in various Iowa State organizations (student government, VEISHEA, homecoming, publications) were the talking points of the Greek houses. For fraternities, the women (the significant others) wearing the fraternity pins were noted frequently in newsletters and updates sent out to chapter alumni. The more pins that were out there and visible, the better. The philanthropy of the Greek community is something of more recent decades—or at least the visibility of it is. Greeks had long been a dominating force in VEISHEA and homecoming, and though activities have come and gone, the Greek community remains a key piece of student social life at Iowa State and bringing social activities to the Campustown neighborhood.

CHAPTER 7

THE STORY OF WEST GATE

When this book began, there were many remarks about the West Gate neighborhood, the community to the west of campus centered on West Street. After World War I, the story shifted to Campustown because, at that point, Campustown became much more defined. Business districts could be defined by a specific district rather than "West Ames." Some people call West Gate a part of Campustown, while others say it's a satellite. And there are those who say it's its own thing. Even though transportation has changed enormously since the first businesses in the neighborhood opened in the 1900s, the small commercial district, which only stretches for a couple blocks, has endured.

West Street is one of the oldest streets in West Ames. It's present on maps going back to the early 1880s, but it wasn't named West Street because of its location to campus. Philander Porter, one of the early settlers of Story County, hailed from Ohio (see chapter 2), but he didn't come alone. His sister, Harriet, had married William West while living in Ohio. They also came to Story County but settled in Ames. The street was named at some point for William West, Porter's brother-in-law, who became the first mayor of Ames in 1870.

The neighborhood is named for the entryway at West Street that becomes Union Drive upon entering the Iowa State campus. The four large pillars that now exist at the entrance—added in the 1920s—fortified the name that had been used for years. West Gate was the starting point for describing where something was to the west of campus. Defining West Gate's boundaries

varies from person to person; here, I'm confining it to the immediate West Street area and ending where West Street forks with Woodland Street. It's limited, I know, but the node along West Street, which shares culture ties to Campustown, is the symbol for the neighborhood. Before World War I, Frank's Place, which opened in 1911, was the first go-to store, selling a little bit of everything. Two years after opening, owner Frank Dixon, whose father ran Ames Laundry Company for years, constructed a new building and added a bakery and delivery service. There were tailors, cleaners and, of course, barbers already in the neighborhood, too. The history told so far is West Gate through the mid-1910s; here's what happened next.

After the Lincoln Highway

The creation of the Lincoln Highway in 1916 didn't have much effect on West Gate. Though there were a handful of businesses on the Lincoln Highway next to campus (on Sheldon Avenue, then North Lincoln Way), the majority of businesses were confined to West Street, which was paved in 1921, and commercial growth remained minimal after World War I. A great majority of the area was large boardinghouses and fraternities. Hyland Avenue and North Lincoln Way (renamed Sheldon Avenue in 1942) earned the nickname "Fraternity Row" for all the fraternities and clubhouses that lined them.

West Gate tried to compete with Campustown's businesses. There was more than one attempt to lure a movie theater (see chapter 3), but nothing materialized. A bank was interested in the area for a bit, too. By the 1920s, as discussed in the previous chapter, some Greek houses were leaving for property south of campus because the homes built west of campus, many of which were some of the earliest homes in the area, weren't made well enough to withstand the wear and tear of college students. West of the neighborhood, the area continued to expand with new houses. West Gate had Clear Creek carving out a rolling terrain nearby that was also heavily wooded. During the 1920s and continuing into the 1930s, Oakland and Woodland Streets were the preferred lands for housing for their countryside warmth.

Many of the big houses stood for decades. Georgia Bluhm spent some summer months of her childhood on West Street with her grandmother Daisy Livingston, who ran a three-story boardinghouse (2811 West Street,

now an apartment building). She remembers frequenting the local businesses and playing on campus with her young relatives, gathering pop cans to buy candy. There were always students walking to and from campus. Her grandmother cooked meals for the students living at her house, as well as made good money as a laundry person and pie maker for the drugstore across the street. The house had a large deck that wrapped around it, and it seemed like Daisy knew everyone who would walk by.

COLLEGIATE PRESBYTERIAN CHURCH

The first church in West Ames was the Friends Church, located at Sheldon and Lincoln Way (see Chapter 5). The second church was Collegiate Presbyterian Church, which has a similar history to other Campustown churches when it comes to attendance and student involvement. In 1902, Reverend Charles H. Purmont spoke at Iowa State—as well as visiting his daughter—and saw a need for a church to be located near campus. Before any other church was founded near campus, Purmont envisioned a town and gown church. On February 21, 1911, the church organized when thirty people met at the home of Thomas Sloss. Purmont raised funds for the church's current site at Sheldon and West Streets, and planning soon began. The church had services at Alumni Hall (now Enrollment Services Center) and later rented Champlin's Hall, the second floor of Albert Louis "Lou" Champlin's building at the corner of Welch Avenue and Lincoln Way. Before there was even a building, the church had to hire a second pastor. The cornerstone for the building was laid in September 1915, and the first service was held in the basement almost a year later. Formal dedication occurred on December 9, 1917. Additions were done in 1946, 1952 (more Sunday school room) and 1959.

Collegiate Presbyterian immediately breathed life into the neighborhood and became its anchor. It can even be argued that the church influenced some people to move to the West Gate neighborhood. The church brought renewed importance to the area, and the name "Collegiate" was chosen to create a connection to Iowa State across the street. As an early church, it benefited, building a large congregation quickly.

The 1950s expansion was brought on by a growing congregation that had reached 1,600 during the decade. The congregation was also composed of many top administrators and professors at Iowa State. The student ministry

was paramount to the church's mission. The original building was large enough to hold the college students, and the facilities meant the church could play an active role in social functions. Falling on the liberal side of the church spectrum, Collegiate Presbyterian has been active in various social justice issues for several years now, but its progressive ways go back decades. In 1935, when there was difficulty in finding men to serve in church leadership, it was voted to allow women to serve as deacons and elders.

The Athletic Drug Co.

The West Gate neighborhood had high expectations for itself when it got its own drugstore. Built in 1915, the Athletic Drug Co. at 2814 West Street, between Campus and Hyland Avenues, was the centerpiece to West Gate upon its completion. At two stories, it was a crowning achievement for the neighborhood. Built by Samuel V. Whittaker, an Ottumwa resident who also built the first business buildings on Knapp Street (see chapter 4), Athletic Drug Co. thrived because of the foot traffic the area received. Run by

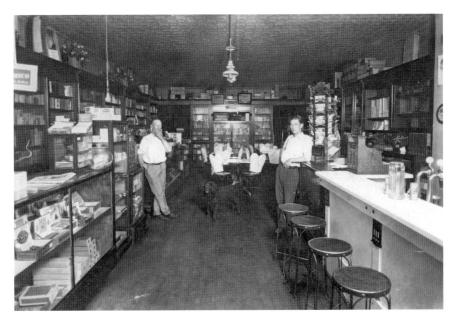

A look inside the Athletic Drug Co. around 1928. The food counter can be seen on the right. *Ames Historical Society.*

Whittaker's nephew R.E. Sloan, it was a full pharmacy with some school supplies and also included a luncheonette and soda fountain and functioned as a post office. The second floor was apartments. A stone nameplate on the building reading "Athletic Drug Co." can still be seen.

The Athletic Drug Co. changed to Peterson Drug Co. after World War II, and a grocery also had space in the building. The name and ownership—Delmar L. Peterson, but everyone called him Pete—lasted through the early '70s. It remained true to its roots with a variety of goods for the neighborhood residents and a short-order counter for a quick bite to eat. Michael LaValle, grandson of the man who opened Larson's West Street Grocery down the street, believes his first hamburger was eaten at the drugstore. Upstairs were apartments, but occasionally businesses would locate there, including a laundry, diner and Tork's tavern.

BUILDING THE REST OF WEST GATE

After the Athletic Drug Co., other buildings followed in the next decade. There once were a few commercial spaces on West Street between Sheldon and Hyland, but those are long gone. Many were torn down from age and as the Presbyterian church expanded. The few commercial spaces that once existed along Sheldon, Hyland and Campus Avenues are also long gone, though a handful of home-run businesses have operated in the area since then.

Only a year after the drugstore opened, a small little building was built right at the northwest corner of West Street and Hyland Avenue. It still stands today and remains the same type of business: a barbershop. The history of barbershops is fuzzy because they aren't always noted in city directories and scarcely received mentions in newspapers. But the local tale that the place has always been a barbershop since it was constructed seems true. It's the ideal size for a barbershop of the time and on a corner just one block from campus—optimal for both students and faculty. The location's most famous incarnations are easily Shipley's Barber Shop, operated by Jason Shipley from 1937 until 1977, and then Monty's Barber Shop, operated by Monty Brown until he retired in 2011. Troy Cakerice has since taken the mantle—the third barber in eighty years. The barbers bring back fond memories of those who grew up in the area. They were the source for news and, in general, great people to have a talk with while getting a trim. The house the

barbershop shares its lot with was built in 1900 and is one of a handful of turn-of-the-century homes in the immediate West Gate neighborhood.

In 1919, the building to the east of the Athletic Drug Co. was built. It was a tailor and laundry for much of its early existence, until the business migrated to Campustown in the 1960s. Through the '70s, '80s and '90s, it was a place for a haircut—Westgate Barber Shop and later the Mane Event. In the 2000s, it took on a new type of business: a deli. West Street Deli has been in operation since 2002 and updated its façade in 2015.

In 1920, another small building was constructed. This one, just to the west of the Athletic Drug Co., would be a grocer in its early years. In the 1970s, it became a bar and has remained one. Known as one of Ames's quintessential dive bars, it started as Tork's, known for a stainless steel bar and only serving Pabst Blue Ribbon. It became Thumb's in the 1990s. Thumb's began on Welch Avenue as Thumb's Up, which operated in the current Subway space. It was a Campustown place where you could see live music on certain nights.

The final building was created by tearing down an earlier structure. The father-and-son team of G.H. and Charles Peyton—and Charles's wife, too—moved to Frank's Place in the early 1920s, but with a growing business, they needed a better building. In 1925, they built the current business building

Built in 1925, this building at the corner of West Street and Campus Avenues was first a grocery store for many years before becoming the beloved Dugan's Deli. It is now Mother's Pub. *Author's collection.*

at the corner of West Street and Campus Avenue, which for years was one of the largest food markets in West Ames. It might also be remembered as a Rite-Way and/or a Jack Sprat Food Store in the '30s and '40s. In August 1952, Guy Larson moved to Ames from New York and bought the grocery store. Guy died less than five years later at age fifty-six. His sons Cliff and Larry took over the store. Michael LaValle, their nephew, believes he turned the store into a place the foodies of today would love. It was one of the few—if not only—places to find imported beers, European cheeses, prime meats and Scandinavian specialties. Choosing to convert the store, it closed in 1972. The mural on the building was painted primarily by Cliff's daughter Cynthia, with some help from her sister Mary, in 1980.

DOOMED BY THE MEMORIAL UNION AND ZONING

The first nail in the coffin for West Gate development was the construction of the Memorial Union in 1928. Though the Memorial Union was only a fraction of the size it is today when first constructed, it was a hub for student activities and social events. There was little chance the Union would have been built anywhere else on campus because Iowa State was expanding residences at the east end of campus at the time. Lyon and Freeman Halls were complete before World War I and Birch Hall in 1923. Welch Hall would be constructed by the end of the decade. Hughes Hall, which is now the far west section of Friley Hall, was built at roughly the same time as the Memorial Union and was close to the center of the two dormitory centers. When the City of Ames passed its first zoning ordinance in 1930, Campustown's business district became much larger than what existed. On the other hand, West Gate's business district, which hadn't spread out beyond a couple blocks in the 1920s, was pretty much stifled from any more growth. Much of what had already developed commercially was zoned C District (local business)—all located on the south side of West Street on both sides of Campus Avenue. The only other place in the city that this zoning was seen was the small node on Knapp Street by the railroad tracks. The commercial node has grown by a lot or two but largely remains the same today. On the board during the zoning process was Lou Champlin. His possible influence to give West Gate such a small commercial sector while giving Campustown—where his business interests were—a large swath of territory must be taken into consideration.

In the past, there had been businesses sporadically on Hyland and Sheldon Avenues, but any chance of them returning was squashed in 1930. To the north of West Street, a D District (business and light industry) was established for the Olsanville Greenhouse property where Briley's Store had been. The Olsanville zoning turned out to be unnecessary because the college would acquire the land a few years later. The space to the south side of Sheldon Avenue included Gilbert's Garage, which was opened in the 1950s by Roy Gilbert. It was later owned and operated by Charles Gilbert.

The remaining part of the West Gate neighborhood nearest to the campus was zoned for multiple-family dwellings. Like Campustown, planners were prepared for the necessary addition of apartments. While many of those old dwellings stuck around for decades, the last fifteen years have seen an immense landscape change as old houses and apartments have come down for the larger complexes. The zone extended to Campus Avenue and the fork for West and Woodland Streets when it was drawn in 1930. It hasn't changed too much in the last eighty-six years.

Recent Years in West Gate

In 1973, the Larson grocery became Dugan's Deli, a delicatessen known for its big sandwiches—especially the Big Mother—and specialty beer selection as well as its nightlife and live music. It gained traction during the era as a hangout for those involved in campus activism, becoming a standout in a group that included Grubstake Barbeque, That Place, the Maintenance Shop and Wutzundar (see chapter 9). Dugan's was a place for everyone; hippies, ROTC men, activists, professors and Greek members all congregated at Dugan's. And despite being frequently at capacity on some nights, there weren't many problems other than maybe being asked to keep it down on occasion. The people were just out to have a good time. The Larsons were quite political and activist themselves. Guy and Esther welcomed politicians on occasion. Cliff, a committed antiwar Democrat in the 1960s, left the store in 1964 to work with Neal Smith in the Iowa legislature, and he was instrumental in creating the proportionate caucuses in Iowa. Larry has served as a state representative and on the county board of supervisors. Dugan's, which closed in the 1990s, would become the Boheme Bistro a few years later. Today, it's Mother's Pub.

Today, all the business properties are owned by Joel Paulson's Mother Lode Enterprises, his final purchase being the corner barbershop property when Monty retired. There's been little change on West Street. At five years, Troy's is still the new business on the block, with Mother's at about seven years. Thumb's goes back to the early 1990s, and Rose Tree Fiber Shop, a crafts specialty shop with a loyal customer base, moved to West Street in the mid-'90s. Paulson and many others are in awe of the changes that have been seen in the last few years. Several of the old homes—many not in good shape to begin with—are gone, and grand apartment complexes have sprung up across the West Gate community. The student population in the area has also soared. Even with the changes, Paulson has no intention of replacing the commercial buildings. He intends to make improvements to the buildings as time and money allow. And though it might have a setback or two, overall, the additional students are a welcome boost to the West Gate neighborhood.

CHAPTER 8

THE BOOM YEARS

Students growing up in Campustown—or really West Ames in general—remember a divide. With the exception of some specialty shops, the Campustown business district could provide the goods you needed. It wasn't until high school that students really associated with the students of the other Ames—"Big Ames," as some called it. Ames was distinctly two separate towns. The one unifying business: the movie theaters.

Iowa State University was a conservative campus coming out of World War II and remained so into the 1950s. The school had a heavy concentration on agriculture and engineering, and campus life was more or less one-size-fits-all. Women lived in the Old Richardson Court dormitories on the east side of campus, while the men lived in the Union Drive dormitories, placing them across the street from Campustown. For students, date nights to downtown were common, but it often meant walking because not everyone had a car. For students, many things were seen as out of their price range, and studies also took up more time. On the quarter system, studies were more intense since material had to be covered weeks quicker than today's fifteen-week semester schedule.

For the local schoolchildren, education began at Louise Crawford School. Built in 1930 as the new elementary school and located just south of Campustown on Stanton Avenue, Crawford, named for a long-serving teacher at Welch Elementary School, was the starting point for local children's education. Nestled in a residential district ("Crawford Means Friends" was the '70s slogan), walking to school was incredibly common—a

Taken around 1959 in preparation for the widening of Lincoln Way to four traffic lanes adjacent to campus, this aerial shows the barren land—and the Squaw Creek—that still divided Ames. *Farwell T. Brown Photographic Archive*.

slice of life numerous children experienced growing up near Campustown (sixth graders were "Big Buddies" to the kindergarteners, too). The students would often play and wander throughout the Campustown district, as well as on the university campus, which they found very inviting, and they had no trouble with the "old" students or faculty. A water tower on South Sheldon was a great climbing temptation for young students—some being caught, some succeeding. There was the train, too, which was at the rear of Crawford School and occasionally came through Ames to drop off coal at the ISU Power Plant. The school grew immensely following World War II and quickly outgrew its own venues and auditoriums.

In 1962, Welch School, which had been both elementary and junior high, became a junior high. It was short-lived and, soon renamed, became John E. Harlan Elementary School. Crawford dealt with the occasional changing of boundary lines but was frequently trying to handle an overcrowding that pushed some students to various annexes. Neither school is in use today. Welch School/John E. Harlan Elementary was torn

down a few years after it closed. It is now the Arbor Hills Apartments. Despite many efforts by local residents to keep Crawford open, it closed in 2001. It was soon renovated for about $750,000 and used as administrative offices. However, those offices have moved to a new complex on Twenty-Fourth Street. Its future is uncertain.

Life in the '40s and '50s

For people growing up in the area, Campustown fulfilled the needs of a family. Several residents knew the owners of the various stores that lined Lincoln Way and Welch Avenue, as well as those on Knapp Street. The shops changed hands, but the diversity of the businesses remained pretty consistent in the years following World War II. The businessmen of the era were known for their Fourth Ward Coffee Club, an informal club that began in 1947 as a twice-weekly social gathering. The members were the who's who of Campustown businessmen—the bigwigs of the neighborhood. Charter members were Andy Maitland (Malander's Grocery), Oscar Trueblood (Trueblood's College Shoe Store), C.M. Peterson (Ben Franklin), Glen Malander (Malander's Grocery) and Connie Stephenson (Stephenson's Dry Goods). Other members joining in the following years included Don Ross (Student Supply Store), Joe Sclarow (Joe's Men's Shop), J.W. Minert (High View Motel), Charles Peyton (Peyton's Grocery & Market), Paul Coe (Coe's Flowers), Howard Thiel (L-Way Café), Jon Morgan (College Town Studio), Norman Lindquist (Lindquist Cleaners), Lew Van Der Wilt (Des Moines Register & Tribune Agency), Erb Hunziker (Hunziker & Furman Builders), Hugh Hostetter (Hostetter's Café), Dean Knudson (College Savings Bank), George Palmer (Palmer Plumbing), Earl Beaty (Knapp Street Store), Ted Landsburg (Landsburg Pharmacy), John Stuckey (College Pipe Shop), Cal Weaver (Weaver's Jewelers) and David Trueblood (Oscar's son). They met in the basement of Trueblood's store (now part of the US Bank) over coffee and donuts, and topics ranged from business and trends to college and high school athletics. A collection was occasionally taken for various charities and people in need. Headed by Oscar, sometimes called the "unofficial mayor of the Fourth Ward" as the district's oldest sole business owner, membership wasn't exclusive to Campustown or the Fourth Ward. Membership cards were even given out to the numerous guests from around Ames. Within five years, the club boasted a membership of three hundred.

At the Barretta building, located at the corner of Lincoln Way and Welch Avenue, was the College Pipe Shop. A pipe store for more than a decade before John Stuckey bought the business from M.W. "Bud" McGuire in 1945, the shop was a common stop for youth despite a not-always-welcoming atmosphere from John. Others speak more favorably of his wife, Esther. But Johnny, often smoking a pipe that gave the store a special smell, tolerated the youngsters, even letting them come in to read comics and then leave. Located above the office for the *Des Moines Register*, where many neighborhood children earned their first dollars delivering papers, the College Pipe Shop was a common pit stop. If it became too busy, Johnny would shoo the children out, or if they peered a bit too closely at the magazines designated as "adults only," it was an immediate dismissal.

Down Welch Avenue was Campus Grocery and Meat Market, and next door to it was Ames Hardware and Music (103 and 105 Welch Avenue; both are Copyworks now). In the 1910s, A.L. Champlin's store was the first to offer hardware to West Ames. When Christensen Hardware closed in the mid-1940s, the area was left without a specialized hardware store until 1949, when Ames Music Center owner Harry Shockey brought his father, from Keokuk, into the business to handle hardware demands. Most memories of the store are because of the music and its booths where you could listen to the records. This was a first-of-its-kind experience for many, as well as the first music store for Campustown.

Archie Wierson's Goodyear Shoe Repair is fondly remembered by many. On top of being a truly welcoming and kind person, Archie made sure his store always had a great selection of shoes. It had been a shoe store since the building's completion in 1927, and Wierson began working at the store in 1937 under the ownership of Peter J. Giannos and became a partial owner upon returning from service after World War II. In 1949, he purchased full ownership and adopted the slogan "We doctor shoes, heel them and save their soles." Even after Archie departed the store, it carried his name until it closed in the fall of 2005. The space remained empty until 2015, when TJ Cups, a teahouse, opened.

The College Savings Bank was the financial center of the district. Several people, including Tom Emmerson, Marcia Campbell, Bob Bragonier and Sherry Erb, recalled going in the bank to open their first savings accounts. Others would go back a few years later for loans to afford college. Led by Charles A. Knudson until his death in 1960, the bank was the business center for landlords and businessmen, too—many walking to the bank on a daily basis to drop off the day's earnings.

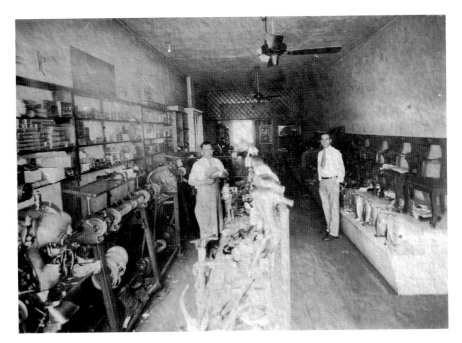

The shoe shop at 107 Welch Avenue, owned here by Pete Giannos, opened in 1927 when the building was built. Archie Wierson bought the store in 1949. It remained in operation into the 1990s. *Farwell T. Brown Photographic Archive.*

Campustown had lots of clothing stores in its former life, such as Bobby Rogers, McCartney's and Town & Campus for women and Bruce-Ross, Joe's Men's Shop, Jameson's and John Huber Clothier for men. There were other types of shops throughout the still-small commercial neighborhood: Ames Sport Shop, Student Supply Store, Coe's Flower and Gift Shop and Stephenson's Dry Goods (several still rave about its fabric selection), as well as the jewelers, Swank's and Weaver (later Magi). The two movie theaters kept quite busy, and a candy store was also located right next door. Hill's Studio was another photography shop, and the five-and-dime Ben Franklin next door was another place for local children to buy their comics; it seems appropriate that Mayhem Comics now occupies the space.

Grocers were pretty common in post–World War II Campustown, Ames Service Grocery & Market, Malander's Grocery and Campus Grocery and Meat Market among them. But the biggest addition came in 1951, when the Ames Supply Food Store opened. With a company rebranding, the business changed its name to Hy-Vee. Located on South Sheldon, the building was built by Joe Whattoff, formerly of Whattoff Motor Co., who

lobbied the growing grocery business to open a store in Ames. Whattoff constructed the building (it's currently the Lighthouse, the campus ministry for CrossRoad Baptist Church), and it is best remembered as the first automatic door in the city. The business, which expanded in 1960, was an anchor for the district for nearly thirty years before heading out farther west in Ames to a bigger building.

For some students, the Memorial Union wasn't always a part of the student experience. Its cafeteria was occasionally a draw, but other events might have taken them to other parts of campus. It wasn't the watering hole it is today. For local youth, the Memorial Union was a place for college students as well as an early job. Working in the cafeteria, at the grill, bussing tables, for the catering service or as general help around the building, the MU employed several high school students. Its frosties were hard to beat at five cents—though Landsberg Pharmacy's selection came quite close—and the place was always packed on Sundays, as families from all around the area ate there after church. Students also took part in the Sunday dining experience and, of course, wore their Sunday best.

The Union was also home to barbers and a beauty salon at the time. Campustown, too, was populated by them around every corner. Once you found your barber or beauty shop (James Buck, Marvin Baum, Ella Walker, Fred and Elida Howard, Lillian Anderson or those in the Memorial Union, to name a few), you stuck with that person. James Buck began cutting hair in Campustown in 1931 at 2414 Lincoln Way. He continued business there for the next sixty-four years before retiring in 1995. He died three years later. Lynn Lloyd remembers getting her first haircut at Buck's: "He'd seen it all." Anyone who went to him remembers him as kind and always conversational. At one time, he had nearly ten chairs and a small staff of barbers.

In Campustown's south was Beaty's Knapp Street Store, owned by Earl Beaty, known for its loose meat sandwiches and housing a small grocery. Located next door was Crawford School. Students remember Beaty as a grouch who didn't like them cutting across his property to get to school, much less coming into his store. Several youngsters returned his attitude by teasing him. One particular event, as told by Martin Edwin Nass in an Ames Historical Society piece, was when junior high students Bob Loomis and Max Wilhelm buried an old practice hand grenade in Beaty's lot. They created a fake map of Beaty's lot with an X marking where they buried the grenade but then littered the map with other Xs, too. At school, pretending they'd just discovered the map, which was given special treatment to ensure it looked authentically old, the two showed off the map as classmates were

A view of Campustown in 1976. The Cranford Building is on the left, with businesses such as Ames Theater, Varsity Theater, Student Supply Store, L-Way Café and Buck's Barber Shop also on the block. *Courtesy of Jerry Litzel.*

awed. In the afternoon, they headed to Beaty's lot to watch Bob and Max dig where one of the Xs was and "discover" a grenade wrapped in oilcloth. The two had to go home, but they left the map with their classmates, whose minds were running wild with what could be at those other Xs. They all raced home to get shovels and went to work digging holes in Beaty's lot. As you can imagine, Beaty was furious when he saw what had been done, and after digging several holes, the others realized the whole thing was an elaborate trick. They'd been had, but admittedly, many got a laugh out of it.

PIZZA! AND OTHER EATERIES

Before 1956, you could possibly find pizza in Ames. A few restaurants had it on their menus, but there wasn't a place that specialized in it. Then Sam and Armond Pagliai opened the Pizza House. The brothers, sons of Italian immigrants, had experience. Sam served his first pizza—or at least "tomato tarts"—in 1953 at a downtown tavern. The food proved to be popular, and the bar earned a name as a food destination. Not long after opening the Pizza

House, the brothers were even making frozen pizzas for a local grocery store or two. Originally at 2502 Lincoln Way (now Copyworks), the restaurant moved next door a couple years later, and for the next thirty years, the Pizza House remained a staple for passersby, who could stand at the window and watch the pizza artists toss the dough in the air. In the earlier days, it was also one of the few places that delivered, making it a favorite for college students; some admitted they ate it often but never stepped foot in the restaurant. When the place closed, there were half a dozen other places to get pizza in Campustown, and even more specialty pizza shops had come and gone since the Pizza House opened.

Like today, plenty of restaurants and diners have come and gone—many, in retrospect, in the blink of an eye. There are those that people still remember. Surviving into the 1970s, Howard Thiel and his L-Way Café remained an icon of the district for years, first opening in the late 1930s. It wasn't too big but was a staple for some on Sundays after church services or on weekends before or after a night out. People recalled Thiel as a quiet man, more likely to be in the background running the place than up front. But he was always around, making him often present during the dining experience. More than a few men remember becoming regulars because of having a crush on a particular waitress. Other Lincoln Way eateries at the time included Sovereign Grill, Cyclone Grill and Campus Café. On Welch was Neiswanger. Down the street from the main storefront strip were some small diners where the interurban track crossed Lincoln Way. The High View Motel was on this stretch, one of the few hotels to appear in the Campustown area. Joy's Spudnut Shop and the Flying Saucer (later Dick & Eva's Café) were next door for most of the 1950s. Around the corner from Lincoln Way on Hayward Avenue was the Blue & White Sandwich Shop, a dive of a place that operated for twenty years. The next business in that space is one that some people still crave: Boyd's Dairy. Farther yet down Lincoln Way were Dairy King and, later, Cyclone Inn.

FOOTBALL AND CAMPUSTOWN

Across the street from Dairy King (and the Cyclone Inn) was one of the lifelines for Campustown: Clyde Williams Field, located where Martin and Eaton Halls are today. The grandstands ran right up to the sidewalks on Sheldon Avenue, and a football Saturday was an environment unlike

Looking north on South Sheldon Avenue around 1970 is the first Ames Hy-Vee, which opened in 1951, and Clyde Williams Field in the background. *Farwell T. Brown Photographic Archive.*

any other. Thousands and thousands of people arrived in Campustown, packing the business district. John Huber remembers the swarms of people shopping and wandering around the district and campus; it's what people did since tailgating wasn't yet on the radar. He would see several former students stopping by his clothing store on Welch Avenue to say hi and see how life was. Other former store owners have similar stories. The athletic events always brought people to Campustown at all hours, and some fast food after an athletic event was part of the experience for many visitors. Post-game Campustown was just as busy as the nightlife set in, too. Of course, parking wasn't easy, but several landowners were there and ready to offer a place to park your car for a small price. Some of Joe Whattoff's grandchildren remember standing outside with him, trying to lure parking seekers to their lots; Joe owned a few properties near Lincoln Way and Sheldon.

Robert Bragonier, who lived on Ash Avenue, remembers standing outside raking leaves on a Saturday afternoon. He could hear the crowd at Clyde Williams Field.

THE FIRST PARKING PROBLEMS

By the 1950s, parking was becoming a major concern in all of West Ames, as well as downtown, but solutions were already in the works. There were parking spots but no regulation on them. Students would park at them and just leave their cars until they needed to go somewhere. While students could get a parking spot on campus, if they lived off-campus, there was little point. The congestion prevented customers from reaching Campustown businesses, so in 1953, business owners petitioned the city council for parking meters. In 1954, the first meters were installed. They were confined to Lincoln Way and the northern block of Hayward, Welch and Stanton Avenues. It still didn't prevent the area from feeling cramped. Between 1953 and 1955, the number of cars registered at Iowa State jumped from 2,439 to 4,280—and that's not including the ones that weren't registered with the university.

Reaching a fever pitch, the city bought pieces of several lots and prepared to build some public parking. One lot, which is still in use, was behind the west side of Welch Avenue, and the other was between Stanton and Lynn Avenues, including the Edwards Coal Co. The Welch Avenue lot originally had twenty-four spaces, and the other lot, which has mostly vanished as

The sculpture *Power Tennis* stands outside the Ames Intermodal Facility, which opened in 2012 and added parking to Campustown. Business owners are wary about whether it is or could be useful. *Author's collection.*

development progressed, contained ninety-one spaces. A good piece of it is now the eastern stretch of Chamberlain Street. Across the street, the Memorial Union's parking ramp was completed in 1967. The current alternating-side parking plan—the side of the street you can park on changes every weekday—was adopted in 1963.

Finding Washington Graham's House

In 1913, Charles Miller came to Ames to join the staff at the Iowa State University department of agricultural engineering. It wasn't long before he began buying up land in the still wide-open Campustown district. Many of his holdings were on the west side of the neighborhood along Welch and Hayward, but he owned land throughout the area. After seven years at Iowa State, he left, going into real estate full time. His office at the corner of Hayward and Chamberlain would remain for decades. Miller isn't someone many people think of fondly. To Dean Hunziker, Miller was a quiet man who often kept to himself, but his presence in Campustown was undeniable. He owned several residences. In 1946, it's noted in *History of Ames Municipal Government* that Miller operated the old Beta Theta Pi House at 129 Welch as an apartment house. Living there were twenty-one families but only three bathrooms—one for each floor. Stories both written and oral say that when he was required to build more baths, Miller put a divider down the bathroom, dividing the shower into two. He's the kind of person who would travel around to turn the heat down at night during the winter and then back up in the morning. He was taking full advantage of the housing shortage that took place after World War II. Many people were desperate for a place to live, so while poor quality, Miller's places were better than nothing.

However, Miller had a fascination with history. As explained in *At the Squaw and the Creek*, not long after arriving in Ames, Miller met Robert McCarthy, the man who made the first Campustown plat. McCarthy told the young Miller about the Campustown district and Washington J. Graham, the original inhabitant of the area who built the first house, which was still enclosed in a current house. McCarthy asked Miller to do something with the cabin if he wasn't around to do so himself. McCarthy moved to Los Angeles in 1925 and died a few years later. In 1951, Miller was assisting in the demolition of a house to make way for the upcoming

In 1977, the Beta House, once home to Beta Theta Pi, was razed. At one time, there were three bathrooms serving the twenty-one families who lived in it. *Farwell T. Brown Photographic Archive.*

Real estate magnate Charles Miller stands alongside his daughter and wife at the Washington Graham house, the first house built in West Ames. *Courtesy of Jerry Litzel.*

Hy-Vee store. During the project, he noticed a smaller house inside and realized he had found Washington Graham's old house. Miller saved the small cabin and moved it to 216 Hayward. The original Dutch doors opened to a divided opening. The floor was the original white pine, tongue and grooved into place, and a trapdoor in the floor remained. The original siding also remained, with a chimney pipe hole cut into it. To use it, Miller built a chimney for the building. The sills, or beams, which supported the house on its foundation were just as they had been.

In 1959, there was talk that if the house could be acquired from Miller, it would be moved to the city park and turned into a museum called the Heritage House. The park board offered to move it. Gladys Mead was the one leading the effort and had people backing her up. She wanted Miller to present it to the town and make it a shrine to the pioneer days of Ames. Ames Woman's Club and Daughters of the American Revolution also had interest in the proposition, but Miller wasn't convinced. He believed the house should stay on its lot, which, while not in its original location, was still on Graham's original property. He also suggested changing the name of Hayward Avenue to Washington J. Graham Avenue. No agreement was ever reached about preserving the building between various parties and Miller, who died in 1966. It was demolished several years later.

CHAPTER 9

CULTURE SHIFTS

The 1960s ushered in a social change. The growth the campus went through during the decades added several new dormitories to campus that reshaped Campustown. Four towers—Knapp, Storms, Wallace and Wilson—added 3,200 students to the south of campus, and the way for them to get to campus was to travel Welch Avenue. Even at this late date, the street was still home to a few Greek houses. However, these new dormitories were an enormous boost. For years, Welch Avenue's development had mostly been confined to the first block and a half south of Lincoln Way. Even then, growth was sparse. A few buildings had sprung up in the decades prior, but in a ten-year span covering the '60s and '70s, a dozen commercial buildings were built, nearly all centered on Welch Avenue.

There was some building before the four towers began. The post office building on Welch and the building to the north with the Campustown mural, painted in 2009 by Ames Collaborative Art and on the cover of this book, were built in 1964. The fire station followed. Some more buildings went up in the 1980s, but little occurred in the 1990s and 2000s.

The demand for apartments for additional student housing led to the creation of the South Campus Area Neighborhood Association in 2002. Residents were seeing more and more families leaving the area and being replaced by student renters. The residents want a good relationship with the renters, and for the most part it is; but they also want to make sure the landlords aren't breaking zoning laws and renting space to too many students (or being lax and not caring how many live on their property). The

At Welch Avenue and Chamberlain Street is the Campustown Clocktower, dedicated in 1994, and Campustown Court, the only public recreation space in Campustown. *Author's collection.*

association began when Fern Kupfer and others surprised a prospective landlord a few days after he admitted to (an undercover) Kupfer, who had recorded him, that he didn't care how many lived at his house, he just needed the names on the lease. The association covers the land to the south of campus, extending to Mortensen Drive.

This era marked the end of retail in Campustown and saw it become a hospitality district as commerce spread across the still-growing West Ames. There are still some goods and services shops, but they are outnumbered by the restaurants and bars. The restaurant business has thrived, naturally becoming a very diverse selection. It's something that Campustown prided itself on in the past, but marketing that had proven challenging, and with the current redevelopment projects, it's a landscape that could vanish.

THE CHANGING 1960S

In the early 1960s, the university was much the same as it had been in previous years and decades, but by the end of the decade, the campus would be much different. As Eric Abbott remembered, a social awakening swept the student body—and the country—as the decade progressed. Residence

117

halls and the Greek community continued to be a dominant piece of social life, but besides the movies in Campustown, cultural events were confined to seven annual events put on by the university. Seeing what was happening in the world—the Vietnam War, civil rights movement, sexual revolution, women's liberation movement—some students began to question why life on campus had to be one-size-fits-all.

During the decade, telephones were installed in dorm rooms, men and women could live in the same dormitory, women's curfew was eliminated—replaced with a keycard—and bars opened in Campustown. Downtown still remained out of reach for many students because adequate transportation wasn't available. While some students had cars, many did not, and the bus was a bit pricey. For students and even some residents, campus and Campustown was the complete culture.

Protests and activism became a part of campus culture during the '60s. For the most part, it was tame and might close down a street on occasion, which included Lincoln Way a handful of times. The only time the tension really mounted was in the spring of 1970 after the Kent State shooting. VEISHEA—Iowa State's annual student-run celebration named for Iowa State's five divisions (Veterinary, Engineering, Industrial Science, Home Economics, Agriculture) in 1922 when it began—was approaching, and steps were required to be taken to prevent any conflicts.

BEER RETURNS AND THE CAVE (FALLS) INN

In 1947, beer could again be sold in West Ames, but only at grocery stores and drugstores. The change came about because state law mandated it—a city can make no exceptions to certain beer permits, which Ames had—and one businessman, who was located in far West Ames, wanted to sell beer. None of the Ames City Council members wanted to allow beer back into the area because of the college students—in loco parentis was still in force—but they did what was required.

For the next twenty years, beer was only obtainable at grocery stores and drugstores in Campustown. Liquor, which the state controlled, was out of reach. Even some university faculty wouldn't buy it themselves—they would have secretaries or assistants do it for them—because doing so required you go to the state-run store and have your name written into the record that you bought liquor. The liquor store was located on South Duff

Avenue, far from campus. For students, beer was often consumed in homes away from campus or outside at parties away from the bustle of the city—woodsies, they were commonly called. They could be out in the boondocks of Story County or even at Lake LaVerne, as some recalled. In 1968, some high school students talked with an *Ames Tribune* columnist about drinking. The students concluded that about 90 percent of boys and about 60 percent of girls drank. With the college students nearby, obtaining alcohol was easy because it was a bootlegging-like business. There were fake IDs and older siblings to help, too; emulating them usually meant taking a first drink in junior high school. They didn't believe they were alcoholics, nor did they find it appealing to get drunk. Their main complaint was that Ames skewed too much toward college students; there wasn't much for them to do on a weekend night.

In January 1967, a new restaurant was going to open at 121 Welch Avenue. Constructed in 1930, the building had been home to many restaurants in its time, such as Cooney's, Hostetter's Café and Neiswanger. The new place was called the Pizza Den, and the owners wanted to be able to sell beer to their customers. In August 1966, the Ames City Council repealed a section of an ordinance so certain West Ames establishments could apply for a Class B beer permit, which allowed the sale of beer for consumption on the premises or to be carried out. Establishments had to be more than 175 feet from a school and church, which put the permit out of reach for The Inn, a small restaurant on Knapp Street that first requested the change in the city ordinance. The restaurant was 172 feet from Crawford School. With two nearby schools, several churches and Iowa State University, south on Welch Avenue was the only place a restaurant could exist and serve beer. On January 31, 1967, the Pizza Den opened, and beer flowed for the first time in Campustown in twenty-five years. Some university alumni have fond memories of the Pizza Den simply because it was a great place to hang out. Its big windows meant you could always peek in and see if any friends were there. There are others who rarely went there. However, Abbott said its opening was a big deal for students because the idea that a place could exist in Campustown where you'd have a beer with friends was finally real.

In November 1969, while constructing Campustown's first bar, one of the neighborhood's most notorious incidents occurred. In 1966, the city built a fire station on Welch Avenue to serve West Ames. Since 1931, the fire station had been under the bleachers at Clyde Williams Field. (In 1966, the traffic congestion at the corner of Sheldon Avenue and Lincoln Way made it necessary to move the fire station, which sounds a lot like today's main

argument made for moving the Welch Avenue fire station.) An unnamed bar and restaurant began building in the fall of 1969 just north of the fire station, demolishing an old boardinghouse to make way for the structure. The hole that had been dug was eight feet below the sidewalk level, and the excavation was going right up to the property line. On the night of November 6, 1969, at approximately 8:35 p.m., the north wall of the fire station collapsed into the excavation hole. One of the four firemen in the building at the time was injured. Lieutenant James Hoffman, an eighteen-year veteran of the department who had been promoted to lieutenant six days earlier, heard a noise and thought he'd check to see what it was. The next thing he knew, the building was collapsing and a brick hit him on the head, knocking him unconscious. He regained consciousness about five minutes later and was taken to Mary Greeley Medical Center. How could this happen? It turned out the plans the contractor was using were different from the ones the city had approved, which called for digging a four-foot hole. The fire station was soon rebuilt, and the restaurant and bar building, which opened in May 1970, found its name: the Cave Inn. (Originally, the restaurant was the Cave Inn and the bar, in the basement, was Rathskeller Lounge, which was a disco at the end of the decade.) Six months after the cave-in, Hoffman, then off duty, was at Ames City Hall when it was bombed, an event that shook the community and remains unsolved. Unscathed, he helped some of the injured victims.

A few years later, billiards came to Campustown when Lucky Q, next door to the Cave Inn, was approved for a billiards license. Yes, in 1972, a license for billiards was required. Two years later, a new building was constructed at 207 Welch Avenue that would become The Library. The bar added Pizza Pit upstairs in the late '70s and became Welch Ave. Station in the mid-'80s, both of which are still in business.

In 1984, a new building at 223 Welch Avenue, located at the northwest corner of Welch and Hunt Street (in recent years, it included Golden Wok and now includes Blue Owl Bar), was the home for the up-and-coming business Duds 'n' Suds. Started by ISU student Phil Akin, Duds 'n' Suds was a laundromat that offered pool tables, pinball machines and beer on tap while you waited for your laundry to finish. Akin started the business in 1982 in a fraternity basement when he was a freshman. With washers and dryers breaking down, he split the profits 50-50 with the fraternity for machines he owned. By the end of 1986, Akin, only twenty-five years old, was a multimillionaire, and Duds 'n' Suds became one of the nation's hottest franchise chains; the company owned eight stores. The company bought

the Lindquist building (recently demolished) on Hayward Avenue a year later for its office. Only a year later, the company was bankrupt and millions of dollars in debt. The company was revamped after a court-approved reorganization. The store on Welch Avenue was open until the late 1990s.

Counterculture's Legacy

The counterculture and activism that took root at Iowa State in the 1960s never vanished. It was subdued on campus for a bit after the Civil Rights Act passed in 1968 and the United States' withdrawal from Vietnam in 1975. By the 1980s, the focus of the student activism had shifted, and Campustown became a fixture in the culture as some businesses became the hubs for organizing activities. Beer became legal (with a license) for Campustown establishments to serve in 1967, and it cultivated a place where friends (or strangers) could go and have a drink and talk about life, current events and how to save the world.

After about forty years in operation, Campus Café was replaced by Martin and Betty Secker's Grubstake Barbeque in 1972. The Library (now Welch Ave. Station) was built in 1974. The Pizza Den became Cy's Roost in 1977. For student activists, these were the watering holes where everyone knew one another, and if they didn't, they would soon. Over on West Street, Dugan's Deli also became one of the popular hangout spots. It housed a tightknit group of people who wanted to lead discussions on gay rights, defense spending and the environment, among other topics, as time progressed through the 1980s. Many places in Campustown were owned and/or operated by people not much older than college students, further instilling a community energized by the young generation.

The Maintenance Shop opened in 1974, providing new opportunities for student debate and activity. Like any student organization, the Maintenance Shop has had its ups and downs as the staff of students has come and gone, but for certain eras, the Maintenance Shop was not only a place for music and beer but also a place for nightly activity. During Dan Rice's time running the venue, he made sure there was something going on every night of the week—plays, debates, movies or lectures regularly discussing the hot-button issues or events of the day.

Grubstake Barbeque would later come under the guidance of Lovish Bederazack and eventually became Café Lovish. It wasn't just the food, which

eventually branched out into Mexican and other cuisines, that attracted people; it was the environment of this and other places. There wasn't a single place where the crowd would congregate but several, and each like a miniature Tammany Hall. Dugan's Deli was a huge hit for everyone in the area. Other smaller places popped up during the '70s and '80s, such as Wutzundar, located in the basement of the building at Sheldon and Lincoln Way (now Dunkin Donuts), and the Underground Café, located at Campus Plaza, 118 Hayward (now demolished).

The international scene got a boost when Claudio Gianello opened Café Beaudelaire in 1990, and the arrival of People's that same year fueled a craze for live music that several places semi-copied. People's, operated by Tom Zmolek, remained the apex of the Campustown music scene. Located in the Champlin Building where Lou Champlin's general store once operated, People's was the hotspot for Campustown in the 1990s and saw many bands take its stage, including local favorites The Nadas, who also performed the venue's final show in 2007. A few years after Dugan's Deli closed, it became the Boheme Bistro, another plus to the international flavor of the district.

When the Boheme closed, the next descendant to carry on the name of a music venue and open public space was The Space for Ames. From 2007 to 2014, Campus Plaza, once home to the Underground Café, was home to alternative publication the *Ames Progressive* and, later, its spinoff The Space for Ames. The small outlet became a concert venue for both local and touring artists on various nights of the week, many of which are fondly remembered by those active in the music scene. It was one of the few all-age venues in the area, too, making it a major draw for high school bands and always bringing in a crowd for its various music festivals.

A NEIGHBORHOOD BYPASSED

The bus services in Ames were hit or miss through the years. For students, they were out of reach financially, and the City of Ames found itself propping up the bus company a few times when the company operating the city franchise failed to break even. In 1981, the city created CyRide, replacing the private bus system. It took a few years for CyRide to find its place in city transportation, and it only slowly began to roll out different routes. However, its greatest impact was in 2002, when it became free for students. Up to that point, it had cost students money to ride, and those

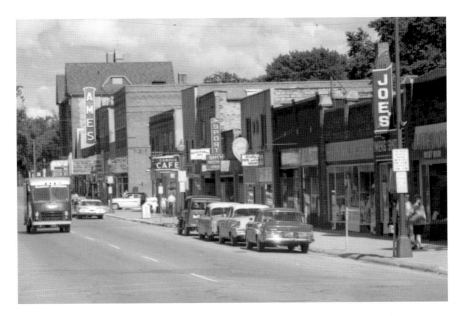

A view of Lincoln Way before the widening in 1963. Some stores here include Campus Café, Joe's Men's Shoe, Ben Franklin, Hill Studio, Jameson's, Wally's Pipe Shop and the Sport Shop. *Courtesy of the* Ames Tribune.

living near campus didn't have a great desire to pay. When it became free for students, the number riding the buses jumped, and for Campustown, that meant less foot traffic.

For residents, automobiles had eliminated being confined to one's local district. While Campustown had many shops they needed, the extra transportation routes made it easier to get around Ames. For years, Lincoln Way was the only way West Ames and Big Ames were connected. By the 1970s, a shift was well underway. In the late 1950s, Highway 30 (which until that point was Lincoln Way) was rerouted south of Ames as a bypass. Arguably, its effects were limited because Campustown prospered because of the surrounding community, not the Lincoln Highway. In a huge project that was eight years in the making, Lincoln Way was expanded to a four-lane road in 1963. This was one reason parking was considered so dire in the mid-'50s; soon half of the Lincoln Way spots, which once lined both sides of the street, would be gone. The process of getting to and from downtown was now a bit smoother. At the same time, Stange Road, on the north side of campus, was changing in the same direction. In 1963, Stange's underpass was widened to four lanes, and then the road was expanded to four lanes to University Village. Ames wouldn't grow in that

direction for several more years, but the plan for it existed. Extending Sixth Street across Squaw Creek to the campus dates back to 1899, but there was a lot of bickering between the city and college to prevent its progress. It took fifty years for the idea to finally see completion. Some viewed it as a sort of unification between the two sides of Ames. Now there were two highly accessible entrances to campus. The connection of Thirteenth Street and Stange occurred in 1926, but connecting Thirteenth to Ontario Street wasn't achieved until the early 1980s. North Grand Mall opened in 1971, luring people who shopped in Campustown.

With a growing number of ways to get to and from Campustown, the customer base was teetering. Those from north Ames didn't even have to bother traveling through Campustown anymore. With the four-lane extension of Mortensen Road to University Boulevard (then Elwood Drive), a south in-city bypass was complete. Campustown was no longer necessary on people's travels across Ames.

BUSINESS DIVERSITY CHANGES

The days of children wandering Campustown and campus are long gone. Times were changing as the 1970s and 1980s began. Many of the long-standing businesses had gone or closed during this era. John Huber was the last remaining high-end clothing store when he moved downtown in the mid-1980s. A few new businesses came about, such as the Campus Book Store, which opened in 1973 and remained an option for student textbooks until 2012.

Campus Plaza, formerly the Whattoff Motor Co. building, opened in the 1970s. Sherry Erb, daughter of Don Whattoff, who owned the building for years, and her husband, Steve, believe the building was an incubator for Campustown. It was the home to the Ark pet store, Maid Rite, an early home for Minsky's Pizza, T Galaxy clothing, Co-Op Tapes & Records, Karen's Plants & Floral, the Little Read Book Shop and beloved cookie maker Do Biz, before it moved to Welch Avenue.

There were still plenty of oddities and treasures that appeared during this era. Four arcades popped up: first (briefly) Cyberia in the early '80s, followed by Space Port, Dark Star and Zapp. Regulars still fondly remember their time spent at them. A few eateries like the Green Pepper, Bagel Works Bakery, Café Shi, Don's Deli, the Pizza Kitchens and Da Vinci's still come

up in conversation as former staples of the neighborhood. The Humphrey Yogart Shop, which didn't last much more than a year, was the first place in Ames to sell frozen yogurt. Co-owner Mark Kassis said it was a tough sell to students in the late '70s.

There were a few obscurities. Studio III was an adult theater located on Lincoln Way (where Leedz Salon is today) that was around for more than a decade. The theater had some difficulties with the city when it was denied a theater license (which was still a thing in 1970), but the owner, Richard L. Davis Jr., won when he took the city to court. The family also ran adult theaters in other Iowa cities, including Des Moines.

After the much-loved Boyd's Dairy closed, it soon became Battle's Bar-B-Q. George Battle, a Texan, had food that regularly had people outside waiting in line. The small dive of a location, which didn't have more than a dozen tables, was packed at lunch, and Battle became an icon. Despite working in a place that had to move fast, Matthew Goodman, who briefly worked at Battle's, described Battle as a guy who seemed like he was outside on the porch sipping lemonade. He knew how to hire the fast workers. After a short battle with cancer, Battle died in January 2006. Now called Battlecry Iowa Smokehouse, it has moved to north Ames to expand but will keep the Campustown location as long as it's able. Kum & Go owns the property and neighboring lot with the intent to build a new gas station.

There was a boom in chain food outlets, too. Dairy Queen, Baskin-Robbins, Hardee's and IHOP appeared in the 1970s, followed by McDonald's, Burger King, Taco Bell, Pizza Hut and Subway in the 1980s. Today, only Subway remains in Campustown. However, an old faded sign for the Hardee's parking lot still sits on a pole in the Battlecry parking lot where the fast-food eatery was located.

If anything remained consistent, it was the two Campustown movie theaters. The Varsity and its midnight movies could draw an audience, and even though *The Rocky Horror Picture Show* bombed upon its first Ames release, it did stellar in its later ones. One memory of Jim Nicholas's was a weekend in the 1970s. At one theater was *The Godfather*; at the other was *Billy Jack*. Both of them had lines that went outside, around the block and met each other on Chamberlain Street on the other side of the block. Despite a sometimes rambunctious crowd, there were never many problems. *Mystery Science Theater 3000* even played at the theater on occasion as a joint project with Mayhem. As the film industry changed, so did the theater's needs. The studios began requiring more and more time that a movie would play, and as a one-screen theater, a bomb at either theater could be costly. In 1996,

The Ames Theater, located on Lincoln Way, was cherished by students and residents. It closed in 1996. Next door was Burger King, once a fast-food staple in Campustown. *Courtesy of Jerry Litzel.*

Ames Theater was closed, while Varsity did a small expansion and split its movie theater in two. Cinemark bought the Ames theaters and attempted to turn Varsity into an arthouse theater, something that had been tried before and didn't work. The Ames Theater space remained closed for several years until Kingland Systems moved in.

THE FIRST VEISHEA RIOTS

Disturbances in and around Campustown weren't new by the 1980s. In the 1960s, there were a couple incidents of post-football celebrations where cars ended up either overturned or in Lake LaVerne. By the 1980s, the committee heading the annual student-run VEISHEA celebration no longer planned concerts since other groups were often doing their own

music events and large parties. There was still a Battle of the Bands and occasionally something of interest but no big evening concert like the Who, John Denver or Sonny and Cher, all of whom played in the 1970s. At the time, the drinking age was nineteen, so most college students could still go to the bars in Campustown. Over the next few years, the number of organized evening activities declined as other student organizations branched out to do their own events, especially the Greek community. Things got out of hand at Ash Bash during the final night of VEISHEA in 1985. Ash Bash, an annual event organized by five fraternities, had kept itself to some parking lots behind Greek houses, but in the early hours of May 5, 1985, between five and seven hundred students took to the streets of Ash Avenue. They vandalized cars and started three fires, one of which was a VEISHEA float. When firefighters and police officers arrived, they were met with flying rocks, bottles and beer cans from the partygoers. No one was seriously injured, and two out-of-towners were arrested for disorderly conduct. At the time, students called it "total mayhem." The event led to university and city officials taking a closer look at the policies for large parties sponsored by student organizations, but no punitive measures were taken against the organizers. Just over a year later, the drinking age was raised to twenty-one.

The first nights of VEISHEA 1988 weren't quiet. At this time, Iowa State didn't have classes on the Thursday and Friday of VEISHEA weekend, and as soon as classes were dismissed on Wednesday, the party climate immediately took root on Welch Avenue. With decent weather and a majority of college students unable to go to the Campustown bars, off-campus parties became popular fast. The trend of thousands of young people from out of town coming to VEISHEA hadn't waned. But now many of those people couldn't go to the controlled environment of a bar, and there wasn't much for evening activity to keep them and their guests occupied. Before the riot on Saturday night and well into Sunday morning, there were smaller disturbances and riots during the nights prior. However, nothing was done to vanquish or control the problems. On Saturday night, a house party south of Campustown began to move to the street and out into the open space of student-dominated Welch Avenue. Soon, the crowd grew to five thousand people, and the flames from a bonfire in the middle of the street soared seventy-five feet in the air. The fire included tree branches, couches, clothes and anything else the rioters could find. For five hours, the riot swelled. Finally, at about 2:30 a.m., Ames police officers were joined by officers of the Iowa State University police, the Story County sheriff and state police and firefighters to disperse the crowd. Several

marched down Welch in a formation line and were greeted with hurling beer bottles, concrete blocks and tree limbs. The force of sixty officers who circled the rioters like military formation wasn't appreciated by the crowd. ISU administrators tried to disperse the crowd, but to no avail. A brick was thrown, just missing the head of then assistant vice-president Warren Madden. About twenty officers were treated at the scene for minor abrasions. "Frankly, I haven't seen anything like this since the early 1970s and the Vietnam war protests. The only difference is those people had a legitimate gripe. These people didn't. They were just drunk," Ames police chief Dennis Ballantine told a *Chicago Tribune* reporter. The riot is most famous for the fact that Johnny Orr, the beloved men's basketball coach, came out to get the students to disperse and go home. That's the story that has stuck, though some people who were there note that the crowd was already dispersing by the time Orr made his appearance. Police arrested forty-five people, and twenty-four people were treated in the emergency room at Mary Greeley Medical Center. ISU president Gordon Eaton said raising the drinking age to twenty-one and recent changes in residence halls' alcohol policies were contributors to the riot. The following year, classes were held on the Thursday of VEISHEA week.

In 1992, the riots came to Campustown. A small crowd gathered near Hunt Street and Welch Avenue to watch police subdue a man resisting arrest. The parties from Theta Xi and Adelante fraternities and Alumni Hall (now Enrollment Services Center) soon spilled onto Welch Avenue, and the spark for the riot was lit. Traffic on Welch Avenue was blocked as the crowd of six hundred slapped people's hands while chanting, "Tastes great, less filling"—the slogan for Miller Lite. They then marched toward Lincoln Way, with some now chanting "Rodney King," as several sneered at the police officers trying to bring the crowd under control. (The acquittal of the four Los Angeles police officers involved in the Rodney King beating was a few days prior.) Other rioters threw eggs, ice and beer cans at the police, while a shirtless man climbed a light pole. Others sat in the middle of Lincoln Way blocking traffic, lighting newspapers on fire and giving out peace signs. For them, this became a peace rally. A portion of the group splintered and marched toward the Knoll, where the university president resides. At its peak, eight thousand people were in the Welch Avenue crowd from Lincoln Way to QuikTrip (now the corner Kum & Go). At 1:30 a.m., Ames police, dressed in riot gear, dispensed tear gas—"The stench of tear gas and alcohol filled the air," the *Iowa State Daily* reported—but the rioters retreated to the back alleys and even atop Campustown businesses, where

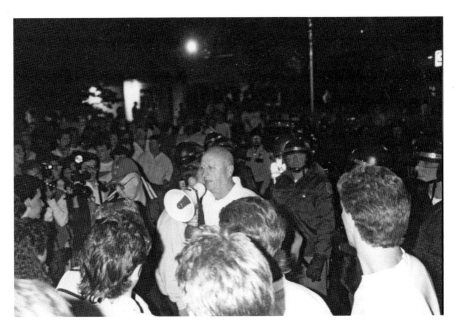

ISU men's basketball coach Johnny Orr arrives at the 1988 VEISHEA riot, trying to persuade the crowd to go home, which had begun before he arrived. *Courtesy of Dan Rice.*

they threw various objects, including a five-gallon jug of grease. When the tear gas cleared, they returned to the streets. After an hour, the crowd still wasn't subdued, but then the police were able to split the crowd into three sections, causing a dispersement. Football coach Jim Walden arrived on the scene and, like Johnny Orr in 1988, pleaded with the students to go home. In 1993, classes were held on Friday of VEISHEA week.

VEISHEA had more incidents in the following years, including disturbances in 1994, 1998 and 2009; a stabbing death at Adelante Fraternity in 1997; and a death in 2012 when a man fell from an apartment balcony. Riots marred the celebration again in 2004 and 2014; the latter officially brought the tradition to an end. Out-of-towners were often viewed as the ones fueling these events—there were often more visitors cited and arrested than Iowa State students—and the deaths were both visitors. However, the 2014 riot was on a Tuesday night (when there were far fewer visitors in town), and the party culture had evolved to more than just VEISHEA weekend. PREISHEA (Pre-VEISHEA) became the name as many partied the weekend before VEISHEA. The annual celebration was a mainstay for many Campustown businesses and always brought a crowd. Despite the fact

that they had to worry about riots and whether they would have windows the next morning, they enjoyed the celebration and the activities on campus, especially the parade.

BIG, UNACHIEVED IDEAS

In the 1980s, Lynn Lloyd and her father, Albert Louis "Lou" Champlin Jr., son of the early Campustown magnate, wanted to do something big with his property, which lined most of Lincoln Way between Welch and Stanton Avenues. With his mother out of her house at 114 Welch (now gone), it was the right time to start anew. They had an architect design a structure and did a feasibility study. The idea was to level everything and build a small walkthrough mall. They had tenants interested, but the only way it worked was with parking, which was the city's task. The city applied for a grant, but when it didn't come through, officials said the parking couldn't be done. Spending so much money on it, Champlin wanted something to show for it, so the entrance of the building was built and would house a couple tenants. However, it didn't work out, as tenants were hard to come by, and the Champlins admit it's the biggest financial Campustown mistake they made.

The Varsity Theater was almost sold to the student government in 2010, but the deal broke down at the last minute. After People's—which had gone downhill financially as fewer and fewer people wanted to pay to see live music—closed, the family spent $800,000 renovating their corner building for a bar and grill: Papa's Corner, which opened in 2008. Even at the prime spot of Campustown, not enough people came by to support it. Future incarnations at the location—Headliner's and Charlie Yokes—fared better.

Kingland Systems, the company that rented the Ames Theater space, eventually bought the entire Champlin block and demolished it for the current building it completed in 2015. Knowing her grandfather's savvy business mind, Lloyd said Lou Champlin would have approved.

CAMPUSTOWN IN THE TWENTY-FIRST CENTURY

Entering the 1990s, Campustown still had some good life in it despite earning a reputation as a district of bars and tattoo parlors—an assessment

that really varies from person to person. The overall business health was still stable, with Mayhem Comics opening in 1990, and Doug Ziminski moved his hair salon, Leedz, next door on Lincoln Way. Grandma's Attic, one of the rare throwback shops, moved its shop to Welch. Copyworks opened at the corner of Welch and Lincoln Way. There was even a magic shop. Student traffic was strong, and of course, there were many pizza options, including new addition Home Town Pizza.

How bright Campustown's future was as we entered the late 1990s and early 2000s depended on who you asked. Some were upbeat, believing better things were around the corner, while others thought the district's best days were behind it and the slow deterioration had no end in sight. The district was certainly in need of a new image as the number of specialty shops continued to decline. When CyRide became free for students in 2002, Campustown foot traffic declined a bit, but when the Towers residences—first Knapp and Storms and then Wallace and Wilson—closed a couple years later, the effect was immediate. Shops like Mayhem Comics once saw a spike in traffic about every hour as students made their way home; about 3,200 students lived in the Towers complex. The new housing emphasis was on Frederiksen Court on the north side of campus.

The Memorial Union food court, replacing the long-running cafeteria in 1996, took some business away from former fast-food places such as Dairy Queen, McDonald's and Burger King, though a couple (Subway and McDonald's) were in the food court, too. For many of these chains, it was the lagging summer months that made the business unfeasible. For Campustown businesses, the fast-food places were a staple because they could always bring people to the district, especially after a sporting event. Without them, there hasn't been much allure for the crowds other than the bars and the remaining restaurants, many of which are ethnic. Jimmy John's and Subway have been able to weather the changes, which included the addition of small cafés in select buildings across campus.

For decades, the university didn't provide Sunday night meals at its dining centers, leaving a gap for Campustown to fill. Students would trek from their residence halls to one of the many restaurants in Campustown for dinner. By 2004, new meal offerings included convenience stores and cafés, which were open on Sunday nights and certainly provided a good option for the thousands of students in the residence halls. The university didn't purposely set out to damper the Campustown business climate. Rather, it was reacting to student demands, which were to be closer to campus and have more dining options nearby.

Nothing the university did was illegal—though some business owners would disagree. The change was part of a national trend and an attempt to keep Iowa State competitive. Iowa law prohibits public institutions from competing with private enterprises, but there are exceptions for universities, such as providing "goods and services that are directly and reasonably related to the educational mission of an institution," which includes food service. Then, in the fall of 2007, enrollment increased and has continued to climb.

The bar scene continues to roll on, but turnover remains pretty common. The District at 2518 Lincoln Way, between Welch and Hayward, has gone through eight names in ten years. Others have proven more stable. Cy's Roost dates back to the 1970s and Welch Ave. Station to the 1980s (though Pizza Pit, its upstairs companion, is older). Es Tas started on Welch Avenue in a small nook of a place before opening its Stanton Avenue location in 2007. Mickey's, Sips, Paddys and Outlaws have also survived longer than typical bar life expectancy. For late-night food, the first street vendor sprang up in the 1990s, though not every business owner has been happy to have them; the facts that they don't pay property taxes and crowd the sidewalk are the main arguments against them. But the vendors have become a staple of the late-night scene, and the Superdog from Smiles and Gyros is one of the quintessential food offerings in Campustown.

In 2008, the Kansas City development company LANE4 Property Group arrived to create solutions for improving Campustown. For business owners, there were strong objections to LANE4's plans, some of which suggested the use of eminent domain, and it created an environment that Campustown had been missing for years. Their resistance brought them together, many for the first time. They communicated and were united against any redevelopment from the firm, which didn't seem to communicate to them well. As the economy turned south, LANE4's project was abandoned. Even student opinion of it was not all that favorable. There were nice ideas—a movie theater, landscaping with College Creek, a big corner pharmacy, more retail space—but whether it would succeed was highly debatable.

There are a couple of tattoo shops still in Campustown. Lasting Impressions, the first tattoo parlor in the district when it arrived in Campustown in the 1980s, left for downtown Ames in 2015. Other Campustown tattoo shops include The Asylum and Jaded Angel.

Kingland Systems' big redevelopment project might just be that spark that some longtime businesspeople have wanted. With the university on board—it rents space on the second floor—and several other projects now having followed, Campustown seems primed for redevelopment. The blocks

A photo of Chasers and the bar Big Shots, 2522 Chamberlain Avenue, from the early 2000s. The bar is now Outlaws, and the house on the left has been replaced with an apartment building. *Courtesy of Jerry Litzel.*

Looking from atop Legacy Tower, the recent and current projects are adding hundreds more students to the Campustown neighborhood. *Author's collection.*

The new mixed-use buildings at the corner of Lynn Avenue and Lincoln Way were completed in 2015. *Author's collection.*

between Welch and Lynn Avenues have been transformed in the last couple years with new projects, and more properties are in progress or approaching the point of pulling the trigger to redevelop. Campustown's population isn't declining anytime soon, too. Apartment buildings now populate much more of the residential Campustown neighborhood than just a decade ago. However, local businesses seem to be getting lost in Campustown change. Upcoming building projects on Chamberlain, Welch and Lincoln Way will soon push out other local businesses, some of which have been around for several years. New buildings have long meant higher rent, and there's nothing in place to promote having local shops in the new spaces. Several places have opened in the string of new shops along Lincoln Way, but they're all out-of-town businesses.

Campustown's future is at a fork in the road. One direction is toward a mix of local and national names to create a culture it has long held or toward heavy redevelopment, but with high-end retail space only a few can afford. Like one hundred years ago, when West Ames threatened to sever ties with Ames, it's a turning point in the neighborhood's history.

SELECTED BIBLIOGRAPHY

Allen, Minne Elisabeth. *Brief History of the Ames Meeting of Friends: From 1901–1944*. Ames, IA, n.d.

Allen, W.G. *A History of Story County, Iowa*. Des Moines: Iowa Printing Company, 1887.

Ames Community History, 1864–1964. Ames, IA: Revenue Division of Ames Centennial Inc., 1964.

Ames Community School District. *Ames Public Schools: 1870–1970*. Ames, IA: Ames Community Schools, 1970.

Ames Historical Society. *Rail Reality: How the Trains Made Ames*. Ames, IA: Blurb Inc., 2013.

Atherly, Mary E. *Farm House: College Farm to University Museum*. Iowa City: University of Iowa Press, 2009.

Badger, Lewis. "Diary of Lewis Badger, August 28, 1859, through July 1959." Unpublished materials. Courtesy the Ames Historical Society and transcribed by Charles Conger.

Biggs, Douglas. "Forging a Community with Rails: Ames, Iowa Agricultural College, and the Ames & College Railway, 1890—1896." *The Annals of Iowa* 71, no. 3 (2012): 211–40.

Biggs, Douglas, and Gloria J. Betcher. *Ames*. Charleston, SC: Arcadia Publishing, 2014.

Brown, Farwell T. *Ames in Word and Picture, Book Two: Further Tales and Personal Memories*. Ames, IA: Farwell T. Brown and Heuss Printing Inc., 1999.

———. *Ames: The Early Years in Word and Picture—From Marsh to Modern City*. Ames, IA: Farwell T. Brown and Heuss Printing Inc., 1993.

Brown, Farwell T., and Kendrick W. Brown. *Ames in Word and Picture, Book Three: Tales from Two Old-Timers*. Ames, IA: Farwell T. Brown and Heuss Printing, 2003.

City clerk's office. *Political History of the City of Ames*. Ames, IA: City of Ames, 1992.

Day, H. Summerfield. *The Iowa State University Campus and Its Buildings, 1859–1979*. Ames: Iowa State University, 1980.

Devine, Jenny Barker. *A Century of Brotherhood: Sigma Alpha Epsilon at Iowa State University, 1905–2005*. Ames, IA: Sigma Alpha Epsilon Fraternity, Iowa Gamma Chapter, 2005.

Gross, George W., Harold D. Zarr and Jeremy N. Davis. *History of Acacia Fraternity at Iowa State University, 1909–2009: Recollections of a Century of Brotherhood*. Dexter, MI: Thomson-Shore, Inc., 2009.

Meads, Gladys H. *At the Squaw and the Skunk*. Marceline, MO: Walsworth Publishing Company Inc., 1976.

Miller, Walter James. *Fraternities and Sororities at Iowa State*. Ames: Interfraternity Council of Iowa State College, 1949.

Page, William. *Fourth Ward: Ames, Iowa*. Prepared for City of Ames, Iowa, Ames Historic Preservation Commission, 2007.

Payne, William Orson. *History of Story County, Iowa*. Chicago: S.J. Clarke Publishing Company, 1911.

Plambeck, Herb, ed. *75 Memorable Years, 1914–1989: Part One of a History of Eta Chapter Alpha Gamma Rho*. Ames: Iowa State University, 1989.

Pride, Harold E. *The First Fifty Years: Iowa State Memorial Union*. Crystal Lake, IL: P.P. & J.A. Sheehan, 1972.

Ross, Earle D. *A History of Iowa State College*. Ames: Iowa State College Press, 1942.

———. *The Land-Grant Idea at Iowa State College*. Ames: Iowa State College Press, 1958.

Schilletter, J.C. *The First 100 Years of Residential Housing at Iowa State University, 1868–1968*. Ames: Iowa State University. 1970.

INDEX

ABOUT THE AUTHOR

Anthony Capps first came to Ames from Oskaloosa more than eleven years ago to study journalism at Iowa State University. He is a freelance writer who has previously worked at the *Iowa State Daily* and the *Ames Tribune*. He intends to keep on researching the Campustown neighborhood.

Visit us at
www.historypress.net
..
This title is also available as an e-book